APERTURE

CROSSING BORDERS: CONTEMPORARY CZECH AND SLOVAK PHOTOGRAPHY

When the former Czechoslovakia freed itself from Soviet rule during the "Velvet Revolution" of 1989, the rest of the world looked on in awe. For many in the West, Prague became an emblem of liberty and a magnet for those who wanted to experience this vital and historic city which was finding a new voice.

Nearly a decade later, the country is divided into two separate states—the Czech and the Slovak Republics. Yet, as the editors of *Aperture* discovered, a collaborative spirit still prevails in artistic circles there. For centuries Prague has been a cultural mecca. Czech and Slovak photographers continue to gravitate to the city immortalized in fiction, poetry, and in the alchemical photographs made by Josef Sudek during the first half of this century. In his essay "The Spirit of Prague," Ivan Klíma offers an insider's view of the native cultures that impart their distinctive flavors to his hometown. Klíma also tells how the "Velvet Revolution" was won. "In the space of a few days," he writes, the citizens of Prague plastered every available surface with posters "that employed ridicule and irony. [They] delivered the *coup de grâce* to their despised rulers not with a sword, but with a joke."

Throughout *Crossing Borders*, photography reveals reality mingled with fiction and fantasy. Nowhere does the hypnotic strangeness of everyday life in the Czech lands seem more evident than in images by Viktor Kolář and Bohdan Holomíček. Each approaches photography from a different perspective: Kolář, the self-described social documentarian, who has photographed the harsh industrial city of Ostrava for more than thirty years; Holomíček, a self-taught photographer who captures celebrations small and large, from his father's barnyard to the president's castle. Jan Novak's insightful essay illuminates a Czech way of life in which simple pleasures expand the capacity for grace, hardship notwithstanding.

The variety of expression in the images here is extraordinary. While many Czech artists in film and literature readily spring to mind, until 1989 photography remained an art carefully concealed by the authorities. As long as photographers kept their pictures to themselves or settled for showing approved work, they were for the most part left alone. During the 1970s and 1980s, these controls provoked a broadening underground movement in Prague in which many of the artists in this publication came of age—but it was an underground isolated from the burgeoning photography scene beyond Czech borders. Existentialist by conditioning, many Czech and Slovak photographers brought irony, absurdity, and wit

to play through images created in what was, both literally and figuratively, a self-made world.

A genre of photography staged for the camera has emerged, particularly among Slovak artists. Originally inspired by the Czech and European new wave cinema during the 1960s, this form evolved in the 1970s and 1980s, when increased repressiveness pushed photographic vision toward metaphorical visual narrative. Among these images, Pavel Pecha's photographic tableaux create a hermetic world that "is not pragmatic or logical . . . [but] filled with fantasy, absurd situations, and play."

Sensuality that transcends eroticism is evident in the work of several artists presented here. During the 1970s and 1980s, they began photographing the body in ways calculated to circumvent official taboos. Among them, Tono Stano's recent nude studies, rendered in obsessive detail, evoke a keen awareness of the tactile qualities of skin, hair, and bone. Ivan Pinkava's sensual portraits, reminiscent of the late-nineteenth-century French photographer Nadar, express the artist's hope "that man's erotic, corporeal nature is not yet lost."

Noted Czech photographers Josef Koudelka and Antonín Kratochvil, who sought freedom in the West around the time of the Prague Spring of 1968, draw upon a perspective born of distance with the native's intimate grasp of custom. Kratochvil's images from the Czech Republic, Poland, and Romania capture haunting rituals of life and death that transcend political boundaries. In recent years, Koudelka has adopted the panoramic format to create lyrical interpretations of industrial devastation in the region known as "The Black Triangle."

That such a volume of creative work originates from a relatively small corner of the world is not surprising given the distinguished history of Czech modernist photography. In his informative essay, Antonín Dufek, curator of the Moravian Gallery in Brno, chronicles the main figures and movements in twentieth-century Czech and Slovak camera work.

The compelling mix of reality and fiction, fact, and metaphor, Eros and Thanatos that comes alive in these pages is unparalleled for its diverse and paradoxical nature. Throughout the process of editing this issue of *Aperture*, a collaborative spirit prevailed that resulted in the images and ideas presented here. We are deeply grateful to the photographers, writers, and many thoughtful advisers who helped bring *Crossing Borders* to fruition. —PEGGY ROALF

Photographers:
Pavel Baňka, Judita Csáderová,
František Drtikol, Jaromír Funke, Bohdan
Holomíček, Viktor Kolář, Josef Koudelka,
Antonín Kratochvil, Zdeněk Lhoták,
Ivan Lutterer, Jan Malý, Pavel Mára,
Michel Pacina, Pavel Pecha, Ivan Pinkava,
Jiří Poláček, Jan Pohribný, Rudo Prekop,
Vasil Stanko, Tono Stano, Josef Sudek,
Kamil Varga, Peter Župník

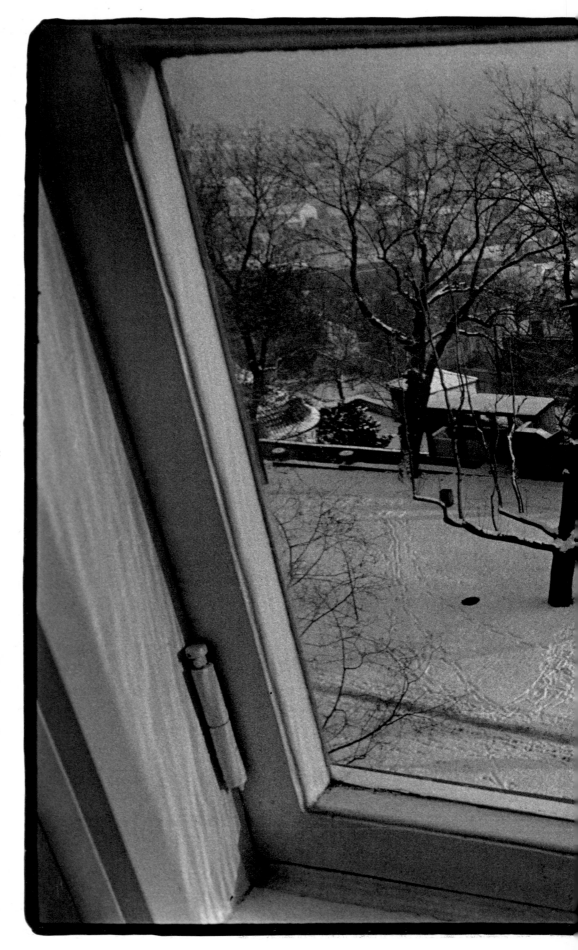

Bohdan Holomíček, Prague, 1994

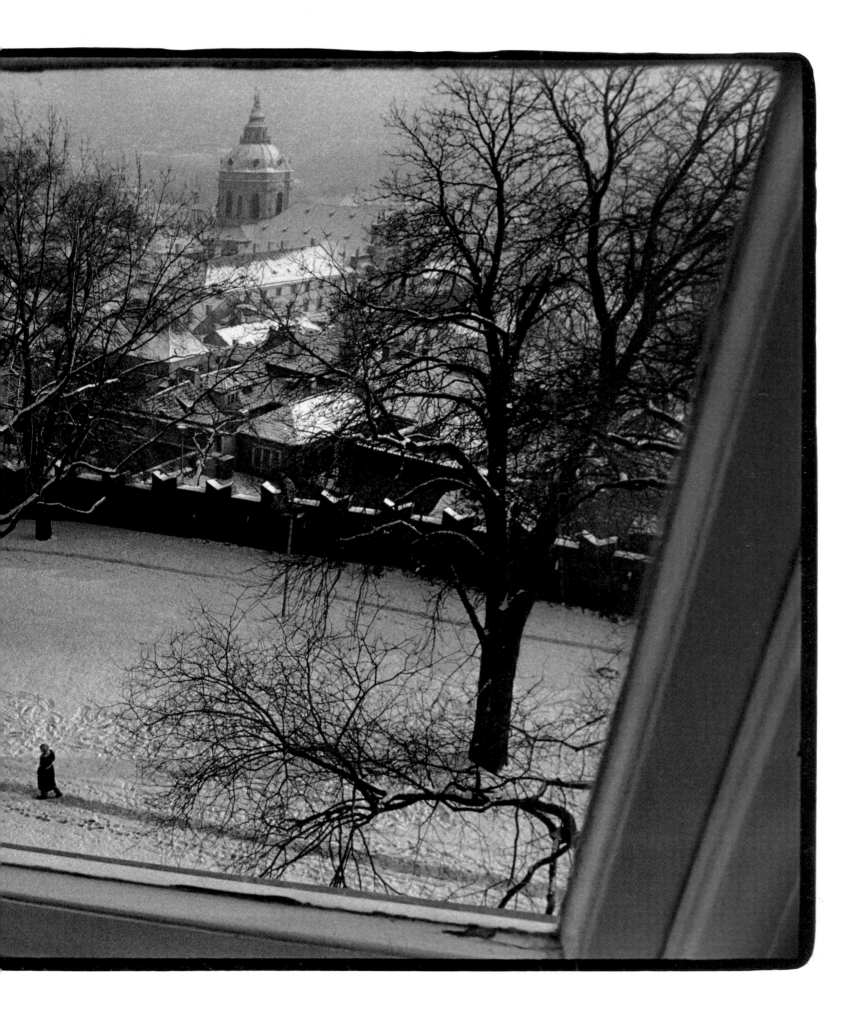

THE SPIRIT OF PRAGUE

BY IVAN KLÍMA

A city is like a person: if we don't establish a genuine relationship with it, it remains a name, an external form that soon fades from our minds. To create this relationship, we must be able to observe the city and understand its peculiar personality, its "I," its spirit, its identity, the circumstances of its life as they evolved through space and time.

Many studies and essays have been written about the spirit of Prague. Books have come out with titles like *Magic Prague* or *Prague, the Mystical City*. The interesting thing is that these books were written by foreigners. The finest and best informed book about Prague I have ever read was written by an Italian, A. M. Ripellino; others have been written by Prague Germans or Jews who, for the most part, had to emigrate from Czechoslovakia to escape the Nazis. Their portraits of Prague, it would seem, have dominated the imaginations of many visitors to my native city. It is the portrait of a mysterious and exciting city that has inspired people's creativity by its ambience, by the remarkable and stimulating blend of three cultures that lived side by side for decades, even centuries: the Czech, German, and Jewish cultures. "*Ich bin hinternational*," punned the German-speaking Prague native Johannes Urzidil. To him, the milieu of Prague had a fairy-tale beauty precisely because you could live here "beyond nationality," because conflicts of nationality cancelled each other out and gave birth to a kind of immaterial, indefinable, mysterious world, a space that could be considered neither Czech, nor German, nor Jewish, nor even Austrian. Urzidil, like many of his contemporaries, drew his picture of Prague and its streets teeming with strolling city-dwellers, but he also depicted a Prague of picturesque empty lanes, nightclubs, open-air stages,

theaters and cabarets, tiny shops, small cafés and, above all, beer halls and taverns, student societies and literary salons, and of course brothels and the colorful metropolitan underworld. Of course this portrait was dominated by the experience of his generation, but also by the remarkable number of great spirits who lived here at the turn of the century. Think only of the composers Dvořák and Smetana, the writers Hašek, Kafka, Rilke, Werfel, Urzidil, Brod, and the politician Masaryk. The Czech and German theaters were enlivened by a generation of great actors and singers; Albert Einstein lectured at the German University; and the Czech Charles University, after a long, arid period, could pride itself on a great many scholars with worldwide reputations in their field. Such an agglomeration of brilliant creative spirits cannot, of course, be explained by external circumstances, for such circumstances contribute only to a place in which brilliance can express itself. But in its dying years, the Austrian empire did provide sufficient room for free creation, and that spirit, as if in anticipation of the impending catastrophe, permeated the life of the city.

But to my mind it was not freedom that most influenced the shape and spirit of Prague, it was the unfreedom, the life of servi-

tude, the many ignominious defeats and cruel military occupations. Prague as it was at the turn of the century no longer exists, and those who might have remembered that period are no longer alive. Jews murdered, Germans banished, many great personalities driven out and scattered across the world, small shops and cafés closed: this is the heritage Prague brings to the new *fin de siècle*.

Of course the spirit that prevailed at the end of the last century and the beginning of this one no longer exists anywhere in the world. It's just that elsewhere, the transition was less drastic and less obvious. But what kind of spirit prevails in the present city?

One of the most striking features of Prague is its lack of ostentation. Franz Kafka (like many other intellectuals) used to complain that everything in Prague was small and cramped. He almost certainly meant the circumstances of life, but it is also true of the city itself, of its physical dimensions. Prague is one of the few big cities where you will not find a single tall building or triumphal arch in the center, and where even many of the palaces, though magnificent inside, put on an inconspicuous and plain face, almost like military barracks, and seem to be trying to look smaller than they really

Josef Sudek, *Prague Castle—View from the Černín Palace, 1950–55*

are. At the end of last century, the people of Prague built a sort of copy of the Eiffel Tower, but they reduced it to a fifth of its original size. In the period between the two world wars, they built dozens of schools, gymnasiums, hospitals, but they did not build a grandiose parliament like the ones in London, Budapest, or Vienna. In 1955

The language spoken in Prague is unostentatious as well. It is full of the vernacular and unlike Russian, for instance, sets no great store by grand emotions. A Czech writer today would hesitate to write that his city was "magical" or "mystical"; he might hesitate even to think so.

the Communists erected a gigantic monument to the Soviet dictator Josef Stalin; seven years later, they destroyed it themselves.

What might have been felt as pettiness or provinciality at the beginning of the century, we perceive today rather as a human dimension, miraculously preserved.

A sense of proportion permeates the life of people as well. Czech life does not go in for a great deal of ostentation, for Barnum & Bailey–sized ads, fireworks, dazzling society balls, casinos, or grand military parades. It tends rather towards markets, seasonal festivals, and simple dances. The showiest celebration used to be the Sokol gymnastic competitions, held in what at the time was the largest sports stadium in the world (it was built on the outskirts of the city so that its vastness would not be disruptive). Such events brought together tens of thousands of gymnasts who would perform synchronized routines in front of audiences approaching 200,000. But even events like this were more an expression of moderation and disciplined enthusiasm than of a longing to amaze the world.

The language spoken in Prague is unostentatious as well. It is full of the vernacular and unlike Russian, for instance, sets no great store by grand emotions. A Czech writer today would hesitate to write that his city was "magical" or "mystical"; he might hesitate even to think so.

In his play *Audience*, Václav Havel tries to give a name to the situation of a banned writer who has to work in a brewery, by using the refrain: "Them's the paradoxes, eh?" The word *paradox* also applies to the spirit of this city. Prague is full of paradoxes. It is brimming with churches, yet only a small number of practising Christians can be found there; it is proud of having one of the oldest universities in central Europe, and a population that has been literate for centuries, but there are few places in the world where learning is so underrated.

Another paradox is the structure that dominates the city: Prague Castle. It is one of the largest fortresses in central Europe, a great

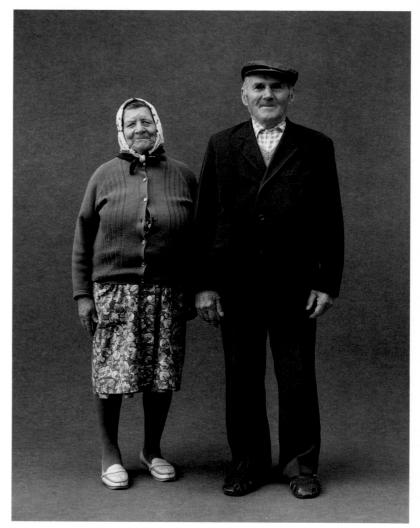

Jan Malý, Jiří Poláček, Ivan Lutterer, Ostrava, 1991, from the series "Czech Man," 1982–1996. Following the tradition of the itinerant portraitist (exemplified by August Sander, from 1911 to 1930, and more recently by Irving Penn and Richard Avedon), the photographers traveled by van to almost every part of Bohemia and Moravia. After setting up their photo studio in a town or village square, they waited for people to drop in. The poses, meant to be natural, were selected by the subjects themselves. Taken over a fourteen-year period, this collection of individual portraits captures the changing attitudes of the Czech people they encountered along the way.

castle that went through its last great reconstruction at a time when the ruler scarcely lived in it. Now it is the seat of presidents. Their fate reflects that of the city from which they ruled. Of the nine previous presidents, four spent more than three years in prison; a fifth was in prison for a shorter time; another (perhaps better forgotten, since most of his presidency coincided with the period of Nazi occupation) died in prison; and the three remaining escaped prison or execution only by fleeing the country. What a strange and paradoxical connection between prisons and the royal castle!

A history that unfolds peacefully seems to flow somewhere beyond people's awareness, but a history full of uprisings and reversals, occupations, liberations, betrayals and new occupations, enters the

Jan Malý, Jiří Poláček, Ivan Lutterer, Ostrava, 1996, from the series "Czech Man," 1982–1996

life of people and cities as a burden, as a constant reminder of life's uncertainties. Prague does not have many public monuments or memorials, but it does have many buildings in which innocent people were imprisoned, tortured, or executed, and they were usually the best people in the country. It is part of Prague's restraint that it does not display these wounds, as though it wished to forget about them as quickly as possible. That is why they are always tearing down monuments to those who symbolized the most recent past (monuments to the emperors and to the first, second, and now even the fourth president, monuments raised to honor conquerors). Streets are also constantly being renamed. Some have had five name changes this century alone. Strangers can walk the streets oblivious to this; a visitor who knows an area can be confused by it and wonder if he has gone astray. Street signs with new names testify to an attempt to purge the city of something it cannot be purged of—its own past, its own history, a history that seems too great a burden to bear.

For a person to bear the burden of his own destiny, and a nation the burden of its own history, patience and perseverance are necessary. A city, too, must have these qualities. In Czech, as in many other languages, the word for "patience" (*trpělivost*) has the same root as the verb "to suffer" (*trpět*). This city, apparently spared the ravages of war, has had to bear greater suffering than many cities directly affected by belligerent action. Unlike foreigners, whose journey usually takes them only to places accessible to tourists, I have been able to enter old buildings and some former palaces and see how self-appointed, barbaric caretakers have allowed ceilings to collapse or have run new walls through magnificent salons and transformed them into company canteens or offices. I have seen terraced gardens that were among the most beautiful in Europe eaten away by the damp; untended flowerbeds left to die; churches turned into warehouses, and finally into spaces unsuitable even for storage. If Prague is still standing and has not yet lost its allure or its beauty, it is because its very stones, like its people, have expressed their patient perseverance.

I have often wondered which place in Prague could be considered its symbolic center. The Castle? The Old Town Square? Wenceslas Square?

For me, the material and spiritual center of the city is an almost 700-year-old stone bridge connecting the west with the east. The Charles Bridge is an emblem of the city's situation in Europe, the two halves of which have been seeking each other out at the very least since the bridge's foundations were laid. The West and the East. Two branches of the same culture, yet representing two differing traditions, different tribes of the peoples of Europe.

The Prague of past eras is gone. No one can bring the murdered back to life, and most of those who were driven out will probably never return to the city. Nevertheless Prague has survived and has, finally, tasted freedom again. Its spirit is intact as well. This manifested itself vividly during the revolution that opened the way to freedom in 1989. Revolutions are usually marked by high-sounding slogans and flags; blood flows, or at least glass is shattered and stones fly. The November revolution, which earned the epithet "velvet," differed from other revolutions not only in its peacefulness, but also in the main weapon used in the struggle. It was ridicule. Almost every available space in Prague—the walls of buildings, the subway stations, the windows of buses and streetcars, shop windows, lampposts, even statues and monuments—were covered, in the space of a few days, with an unbelievable number of signs and posters. Although the slogans had a single object—to overthrow the dictatorship—their overtone was light, ironic. The citizens of Prague delivered the *coup de grâce* to their despised rulers not with a sword, but with a joke. Yet at the heart of this original, unemotional style of struggle there dwelt a stunning passion. It was the most recent and perhaps the most remarkable paradox to date in the life of this remarkable city.

Translated from the Czech by Paul Wilson

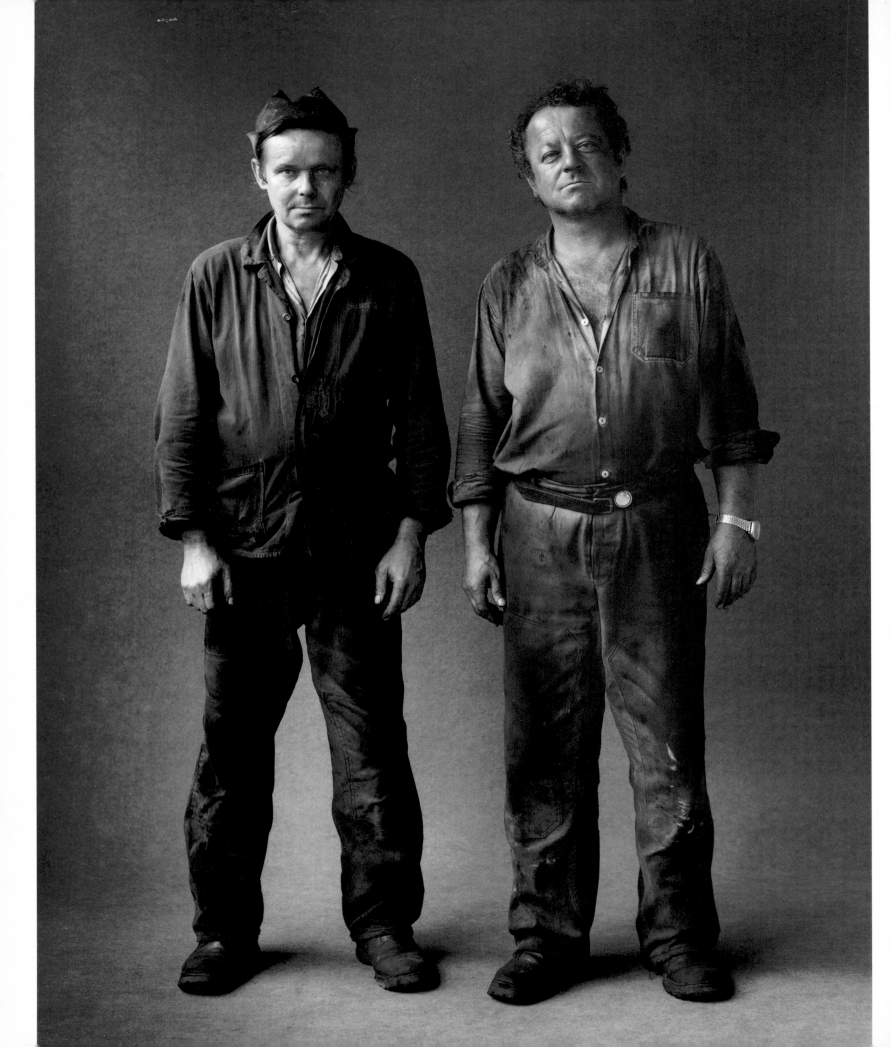

MOMENTS OF GRACE

BY JAN NOVAK

The rusty railroad bridge soared twenty-five feet over the dark swirls of the Elbe River, and jumping off it was the chief rite of passage in my hometown of Kolín, Czechoslovakia. Once you could do that, you were cool. Later, when the heart-pounding thrill wore off, we'd wait for a train to thunder up behind us, moon the passengers, and leap off as a group.

I hadn't thought about those summer days for years, not till I saw Bohdan Holomíček's photograph of six boys jumping off a bridge in the village of Žehuň, but then it all came back—the whoosh of hot air, the slap of cold water, the frantic fight against the strong current as I try to reach the nasty discharge pipe of the electric plant, which gushes warm water the color of creamy coffee and which is the closest we ever got to a Jacuzzi back then.

That was in the '60s, a long time ago. Now I live in America and exist in English, yet somehow Holomíček's photographs stir up my old Czech self. Perhaps it's because his black-and-white images examine what is normally lived too close to the viewer to be noticed at all, or maybe I'm simply drawn to the quiet poetry of his generous observations, but ever since I saw Holomíček's work I've been curious about the man who saw so much in the gray tones of everyday life; so when I went to Prague recently to publicize a book, I decided to meet him. On the phone, Holomíček sounded as kind and friendly as his photographs. He told me to meet him in a bar called Tragedy in a theater called Comedy where he was shooting production stills that afternoon.

Our first encounter is now a smear in my mind: Holomíček is tall, bald, wiry; he dresses casually, wears a graying reddish beard. He grins widely as we shake hands, and I realize that his right hand is crippled, that his fingers may all be there, but they're somehow frozen into a stiff claw (when he was five, Holomíček stuck his hand into a weed cutter and another boy turned it on, severing the ligaments on three of his fingers), and before I get over this first impression, Holomíček is already taking pictures of me, his head bopping around the camera as he considers the light with quick cutaway glances, and then he reaches out, firmly grabs my chin with his claw, and turns it to the lamp, "That's it, right there, don't move!" The next thing I know, we're drinking beer straight from the bottle and a young actress is pulling on Holomíček's sleeve, she doesn't know how to say this, but she'd do anything to get a portrait done by him, she'll even pay money for it, "Okay, so let's go upstairs, there's a corner with a nice window there," Holomíček gets up right away, but this only causes the actress to wince, "What, right now?" oh no, she couldn't possibly right now, she hasn't even washed her hair, "But so what? That's good," says Holomíček, "at least you'll have a record of exactly how you were today," he grins

disarmingly, and suddenly it all makes sense to the young woman and she walks off with him—and I realize that here it is, this is the Holomíček touch: part openness, part generosity, part sympathetic curiosity, part furious energy, part superb eye. This is what has, over the past thirty years, allowed him to map Czech society from the bottom to the very top, from drunken cowherds to drunken future presidents, with artists, cops, paraplegics, hockey players, kids, grandmas, truck drivers, scholars, and blind men in between. He has recorded the passage of time on his own family, captured dreamy landscapes, and snapped the picture of every hitchhiker he has ever picked up, keeping a visual diary of his own life in the process.

"I don't think of myself as a photographer," he told me. "I just live my life and take whatever pictures come my way."

Two days later, I find myself in the kitchen of his parents' house in the village of Mladé Buky. They are serving homemade pickled beef with dumplings for dinner, and the kitchen is warm, the beer is cold, and the family pictures on the wall are stunning.

Holomíček's folks are eighty years into their very hard lives. His tiny mother never leaves the side of the steaming stove, never stops talking. His stocky father never leaves the chair opposite the old TV set. He is almost completely deaf.

"I thought Bohdan was going to grow up crazy, the things that he went through as a little baby," Mrs. Holomíček tells me. Her son was born in 1943, in a Czech village in the Ukraine, not far from the city of Lvov. The war was on and the Germans controlled the area. They were a brutal occupying force. "I didn't have a lot of milk," says Mrs. Holomíček. "We were constantly grabbing our cow and running and hiding in the forest from the Germans." The Wehrmacht soldiers had already murdered three of her brothers. "There was so much shooting, explosions, blood, hunger, I didn't think my boy could ever be normal."

After pushing the Germans back, the Red Army took Holomíček's father with them and made him an artillery spotter, for the fine eye that clearly runs in the family. Back home, little Bohdan "used to go out to the yard all the time and just stand there yelling, 'Daddy!'" reports Mrs. Holomíček. "And it worked. One day he got his daddy back."

Curiously, it's a moment Holomíček doesn't remember, though he does recall the train that took their whole village back to Czechoslovakia, the old country that these Czech-speaking, Ukrainian-born farmers had never seen. It was 1947 and the Ukrainian Czechs were needed to replace the Germans, who had been expelled from Czechoslovakia after the war. They were also briefly getting away from Stalin.

The Holomíčeks boarded the train with a couple of cows and a few sacks of flour. They were dropped off under the Krkonoše Mountains in the north of Bohemia, where they remained. They

Jan Malý, Jiří Poláček, Ivan Lutterer, *Skalna*, 1996, from the series "Czech Man," 1982–1996

worked on a farm. They raised rabbits, hens, pigs, cows. They had a couple more kids. Bohdan stuck his hand into the weed cutter. They built a house. They simply lived a life. It never occurred to them that theirs was a tough way to do it.

All along, Holomíček photographed his family. They barely noticed the pictures that were documenting their days. At first even he hadn't really valued the pictures he was snapping. He was simply learning how to use the camera. He intended to learn the skill and then employ it to make "art." It took him a while to realize that his best pictures were "these off-the-cuff, throwaway shots and not any of those self-consciously made images" he had been working so much harder on.

At the age of eleven, Holomíček made his own darkroom under a staircase, exposing his pictures by opening the hallway door. He read all the books on composition he could find. He learned by trial and error. He joined photography groups, but he also danced, ran track, and climbed mountains in spite of his mangled hand. He liked mechanical things, could fix almost anything, was a ham radio operator. Most important, he started to take his camera everywhere he went.

It never occurred to anyone in Holomíček's family that you could make a living by taking pictures. He became an electrician and worked in a nearby power plant for eight years. Later, he got a job in the heating plant of a small ski resort, Jánské Lázně, where he was the maintenance man for twenty-three years. He also supervised a group of eight stokers who kept the town's furnaces humming. He stepped in and shoveled coal whenever one of his stokers called in sick.

He quit the job in 1994 because he was finally making enough money with his camera to survive, but he still lives at Central Stoking 1, a boxy brick house by the gate of the heating plant. It's here that Holomíček seats me by a sturdy table and starts lugging boxes of prints up from the basement. His young wife has seen them all, so she prepares a couple of cheese plates for us and goes to bed. Bohdan brews the tea and pours the whiskey. I look at the pictures, printed on all manner of paper, some of it as soft as a typing page. It's a dazzling show, God's plenty as it manifests itself in the Czech way of life.

Whenever I get stuck on an image, I discover that there's a story that goes with it: "Oh, this guy here, he's blind. This was in the town of Kladno and I couldn't bring myself to just snap a shot of him, so I asked him if he'd mind. He said he wanted to 'see' my work first. So I pulled out some prints from my bag. The guy takes them, he runs his fingers over them, he nods, as if to say this is all right, and then he asks me what car I'm driving." Holomíček drives an old Škoda 120 beater. "So I take him out to my car and he says, 'Could you open the hood?' 'Sure,' I say, and he starts touching the engine and tapping on all the cables, just feeling around under that hood. It was beautiful. And then, when his hands were all black and his face was smeared with oil, he said: 'Okay, you can snap your picture anytime you're ready.'"

No wonder Holomíček dismisses photographers who tiptoe

Bohdan Holomíček, *Just Being*, 1982

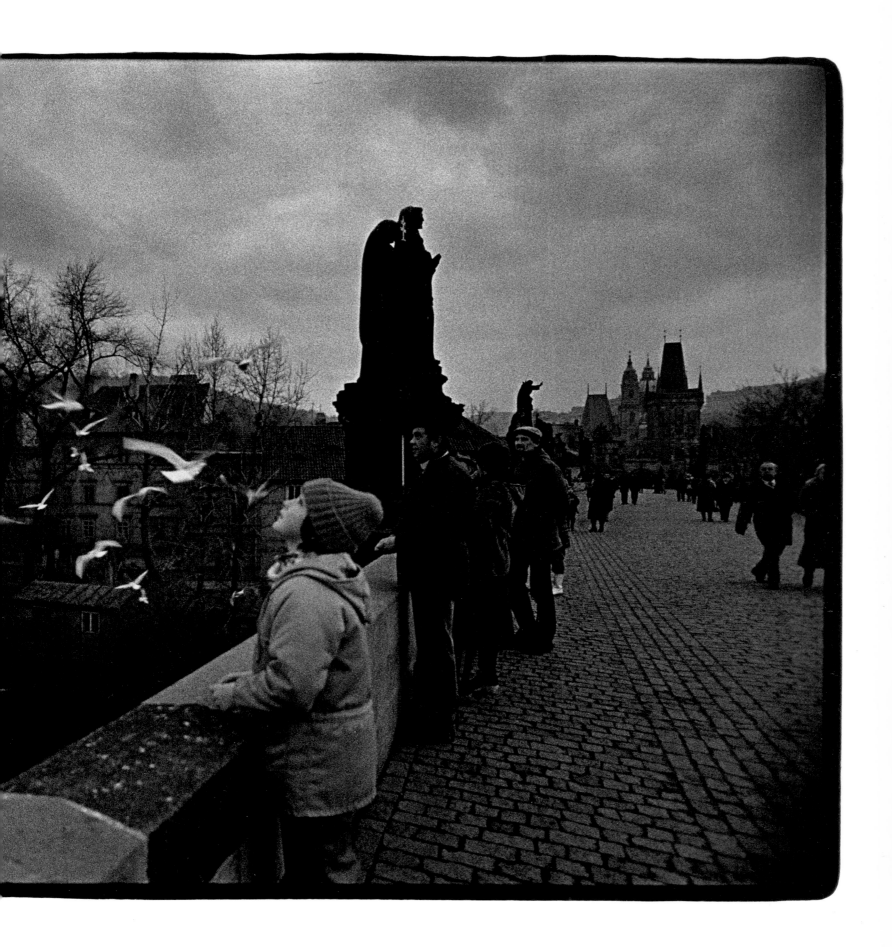

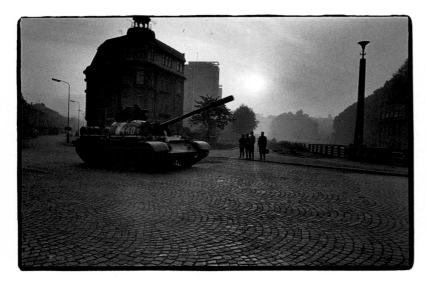

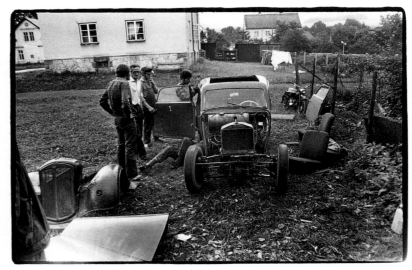

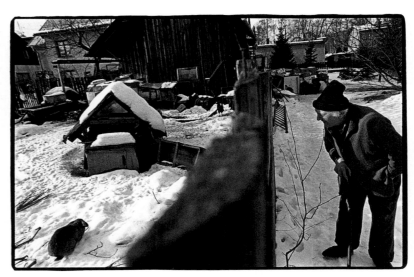

All photographs by Bohdan Holomíček

Top left: Trutnov, 1968
Top right: *I bought it from the butcher*, Mladé Buky, 1966
Middle left: *Inauguration*, Prague, 1993
Middle right: *Dad got him for Christmas*, Mladé Buky, 1997
Bottom left: Blahuška, Čáslav, 1976
Bottom right: Jarka Těšínská, Litoboř, 1993

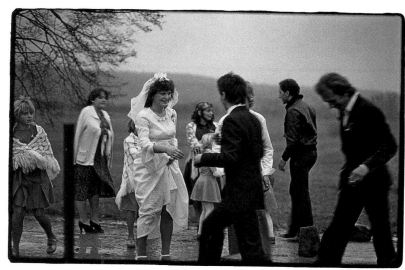
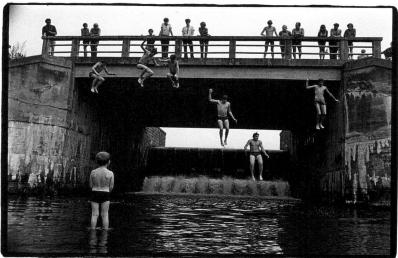
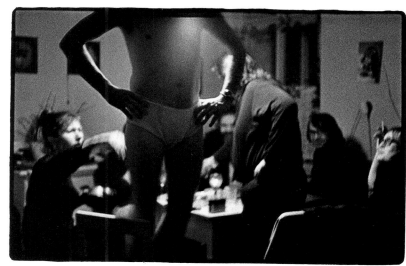
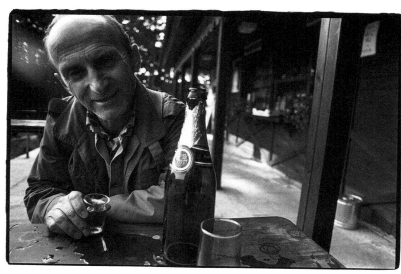
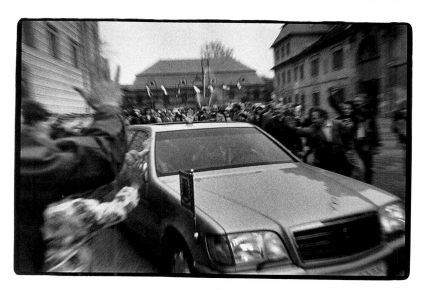

Top left: Svoboda N. U., 1997
Top right: Nowadays, they don't live together anymore, 1982
Middle left: Žehuň, 1973
Middle right: Easter at the Reverend Kukuczka's, Hostinné, 1975
Bottom left: After the night shift, we went and got a breakfast, Jánské Lázně, 1990
Bottom right: Mr. President is leaving, Litomyšl, 1993

through the world, surreptitiously stealing images and hurrying on. He calls them *Leicaři,* "the Leica boys."

As the night grows old, first the whiskey and then the homemade slivovitz run out, but we never run out of photographs. "I don't have any themes," Holomíček shrugs his shoulders. "I take pictures of any- and everything. Maybe I stop and shoot the sunset, then a hitchhiker, then myself as I'm going to take pictures of a theater production, the theater building, the actors, the security guard by the door, the full moon on the ride home." He is the raging documentarian who senses time slipping through his viewfinder, and his passion costs him. He never has enough film and printing paper. "I just give away most of my prints," he says, "but it's funny, somehow the pictures often return and pay me back in strange ways."

The sheer number of images is a problem Holomíček struggles with whenever he exhibits his work. He has shown his pictures all over the Czech Republic and has slowly acquired an international reputation. In galleries he usually ends up arranging his prints in long bands around the walls. He mounts them three or more rows high so that they can yield their stories about the passage of time, flickers of friendship, sudden connections, passing attractions, moments of grace. He pushes the narration even further by jotting masterful captions in the borders of his prints. "I usually don't write my captions till folks are already knocking on the door of the gallery," he says, "This forces me to be quick and automatic in what I say. Sometimes I'm not sure of my Czech grammar, so I have to keep it as short and simple as possible."

At four A.M., in the hour between the dog and the wolf, I stretch out on the sofa and crash. When I come to again, three or four hours later, Holomíček has a pot of tea brewing on the table. I reach for the next box of prints. The images are as strong in the daylight as they were at night, and I wind up looking at Holomíček's pictures all day. I never get through all the prints, but I never get enough of them either. Then, suddenly, the last bus is about to leave for Prague. We jog to the station, with Holomíček greeting everybody on the street. "What're you, off to Nagano now, Bohdan?!" an old lady in a wheelchair hollers after us.

I am the last person to board the dirty diesel bus. The last thing I see through the closing door is Holomíček, snapping another picture of me while pleading with the driver: "Will you be nice to him, please? He's had a horrible time here! He hasn't slept for a couple of nights!"

I wave through the mud-splattered window, remembering how Holomíček described the greatest revelation he has had as a photographer. It was back in the early '60s and he was strolling through an exhibit, a young man trying to steal the secret of the art of great photographers, when it suddenly came to him that "the thing is not to think about photography, but to think about the people you photograph," for this is the essence of the Holomíček touch; this is how he engenders all that natural intimacy and trust; this is why his pictures have such depth; this is why they discompose my memories; and this is also why the bus driver suddenly turns to me, points to the front seat, which is blocked off by his leather pouch, and says gruffly: "Just throw that bag on the floor."

Bohdan Holomíček, *Isabela,* 1986

14

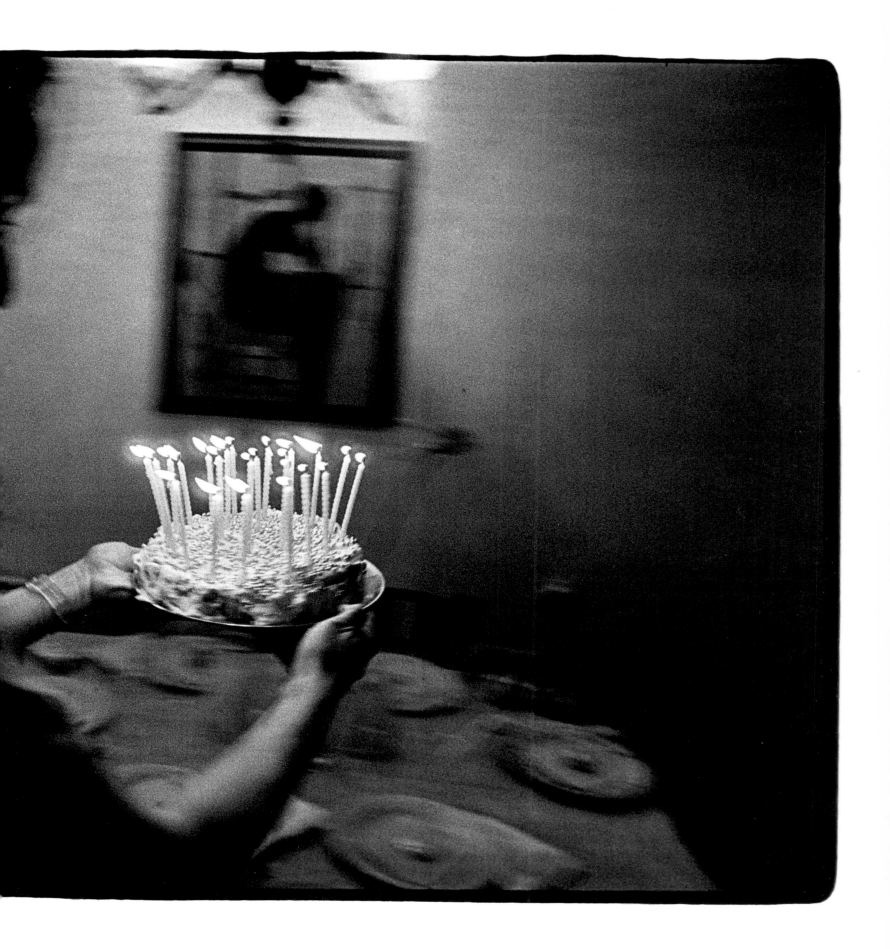

BETWEEN EARTH AND SKY

I live in two worlds. One is real, the other is a response to negative qualities in the first—but is a realm apart. This domain is constantly changing, developing. I enter little by little, maybe voluntarily, perhaps by necessity, because this world is far better than the real one. It is not pragmatic or logical, neither intolerant nor superficial. It is filled with fantasy, absurd situations, and play. When reality is harsh, violence and evil can also appear here.

In this world, I discover strange situations, surreal pictures, unexpected relationships. Sometimes there is an idea, a sudden gleam; at other times, just a feeling, a touch of transcendence. Then, like a mosaic, the inexplicable picture forms, perceived gradually through subconscious meditation. Still, the most beautiful pictures remain in my head.

My world constantly changes, yet something from it remains forever. It shows me the way. My existence becomes an odyssey between these realms, a passage between sky and earth. More and more often I reside solely in my own world. No longer earthbound, I feel that I shall never return.

—PAVEL PECHA

(Photographs on pages 16–21)
Pavel Pecha, from the series
"My Intuitive Theater," 1990–94

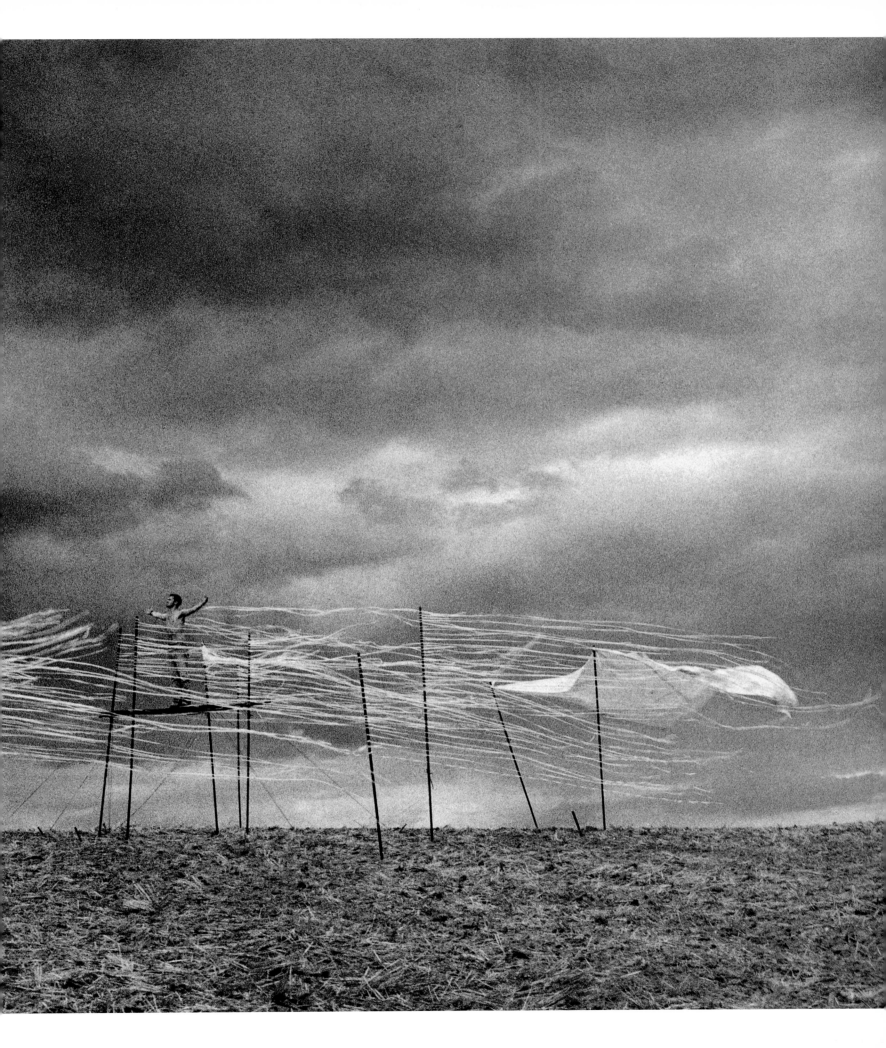

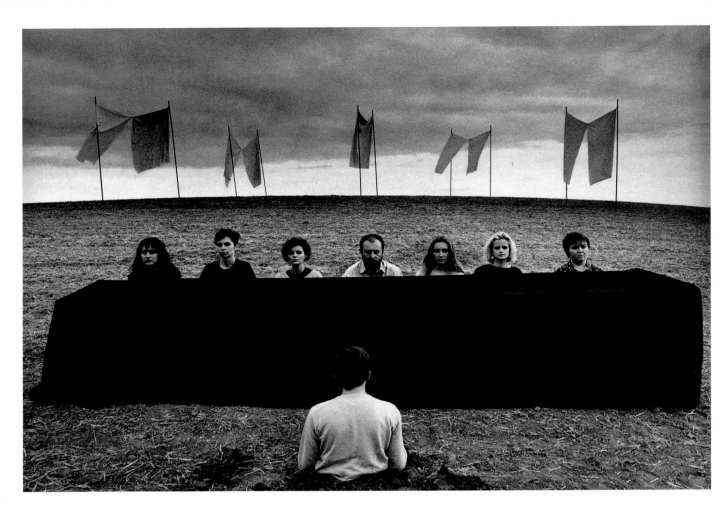

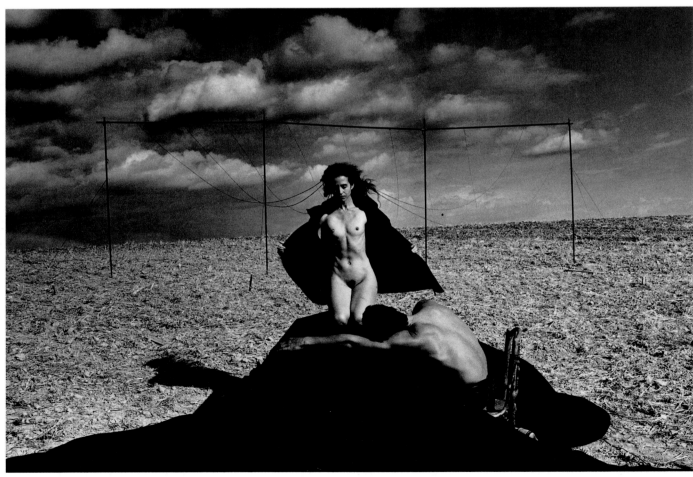

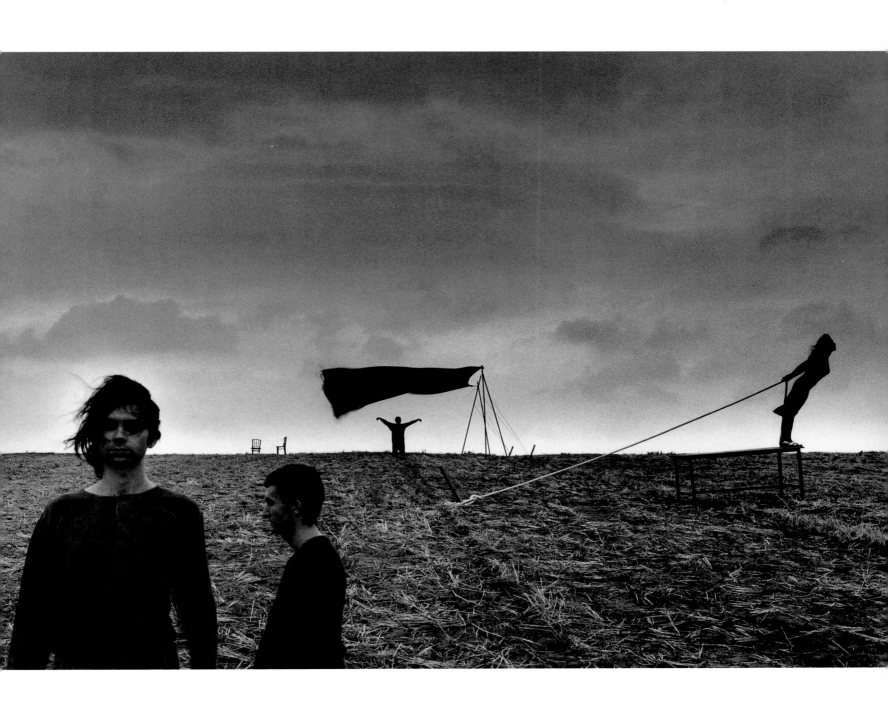

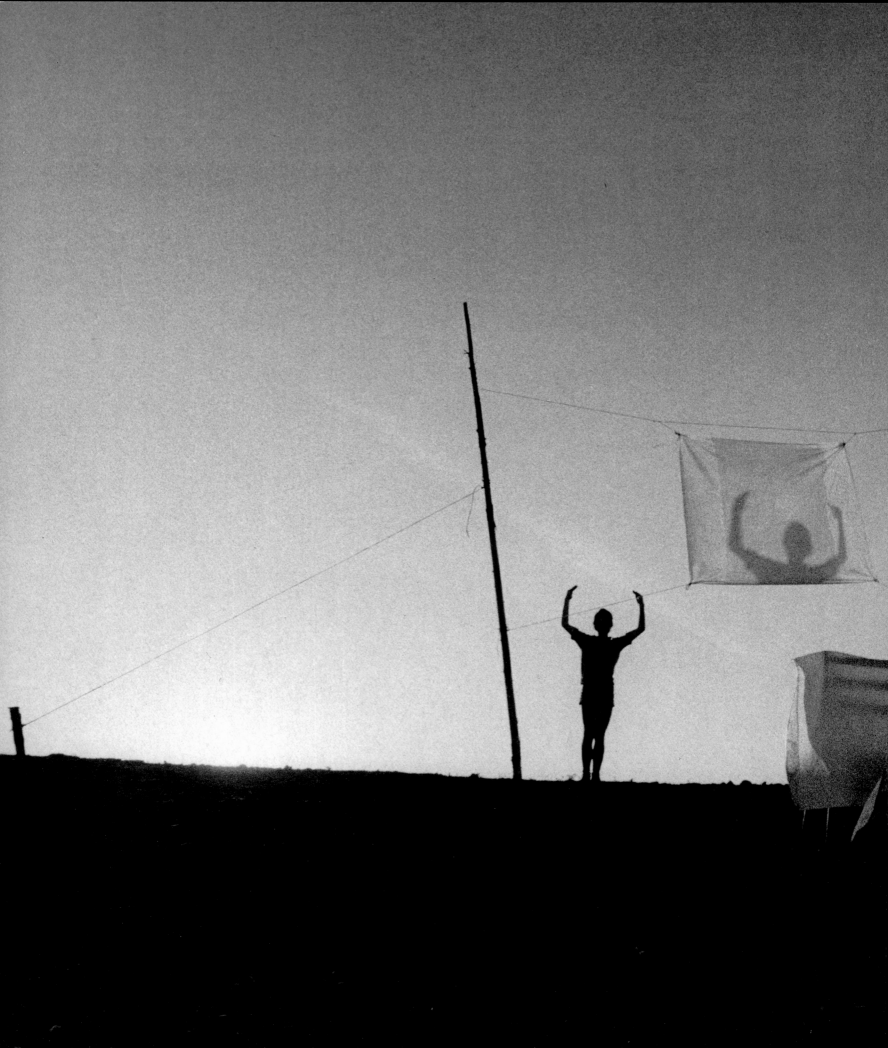

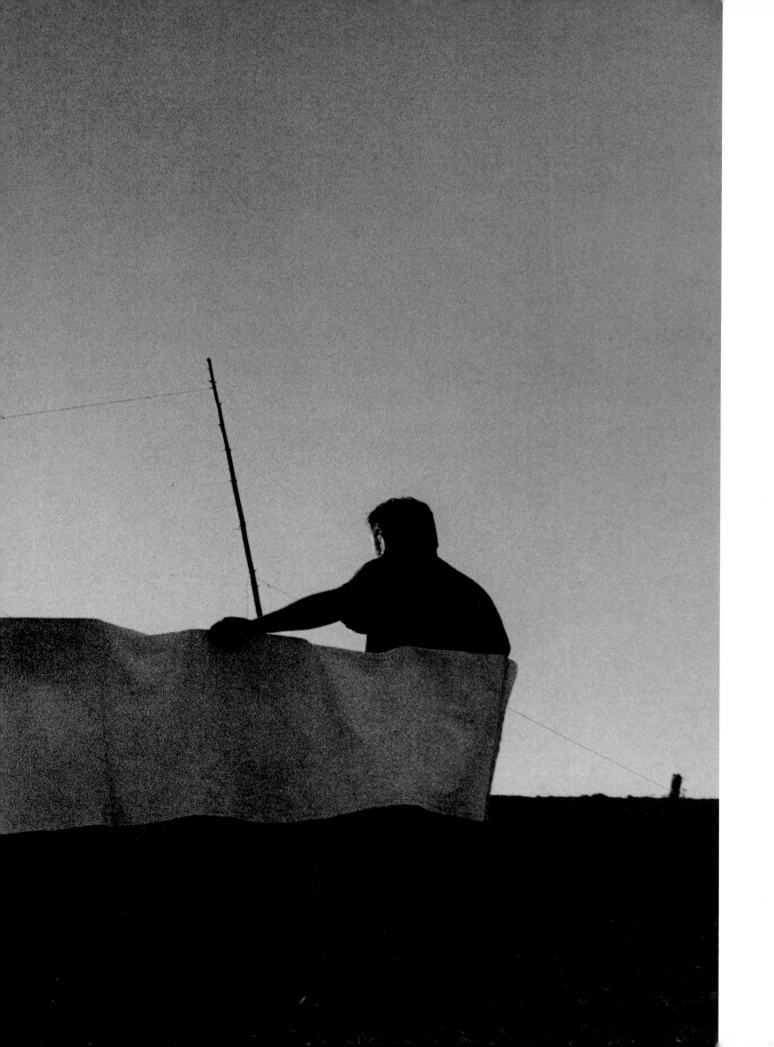

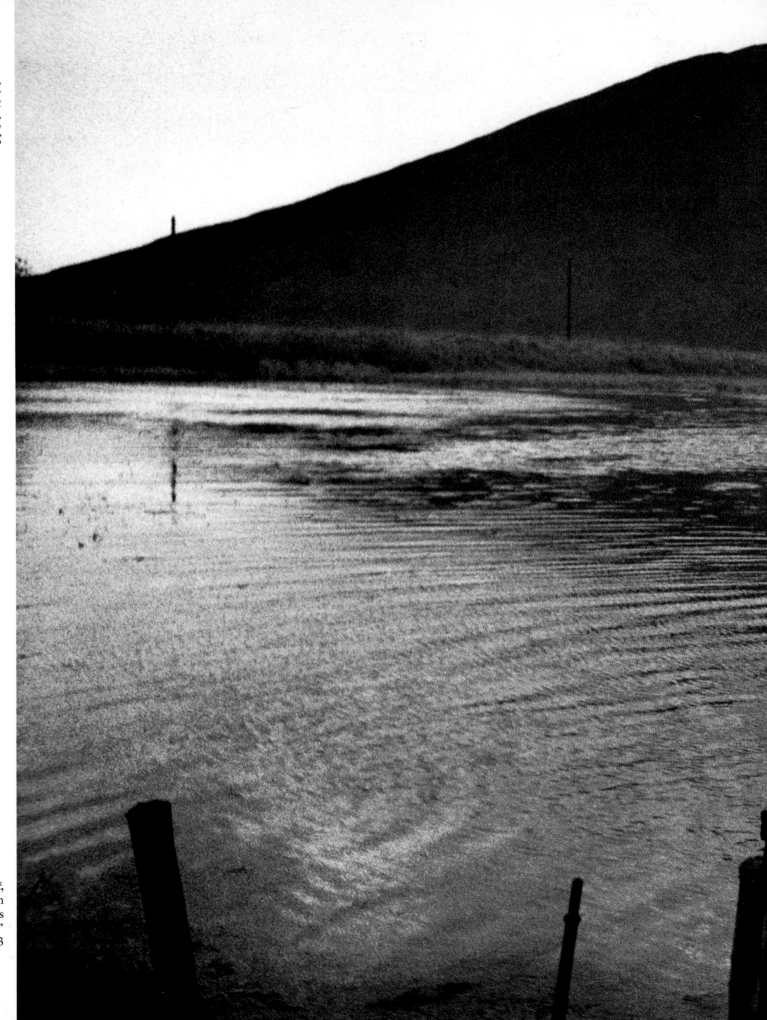

LIFE
AMONG
THE
ASHES

Viktor Kolář,
from
the series
"Ostrava,"
1966–1993

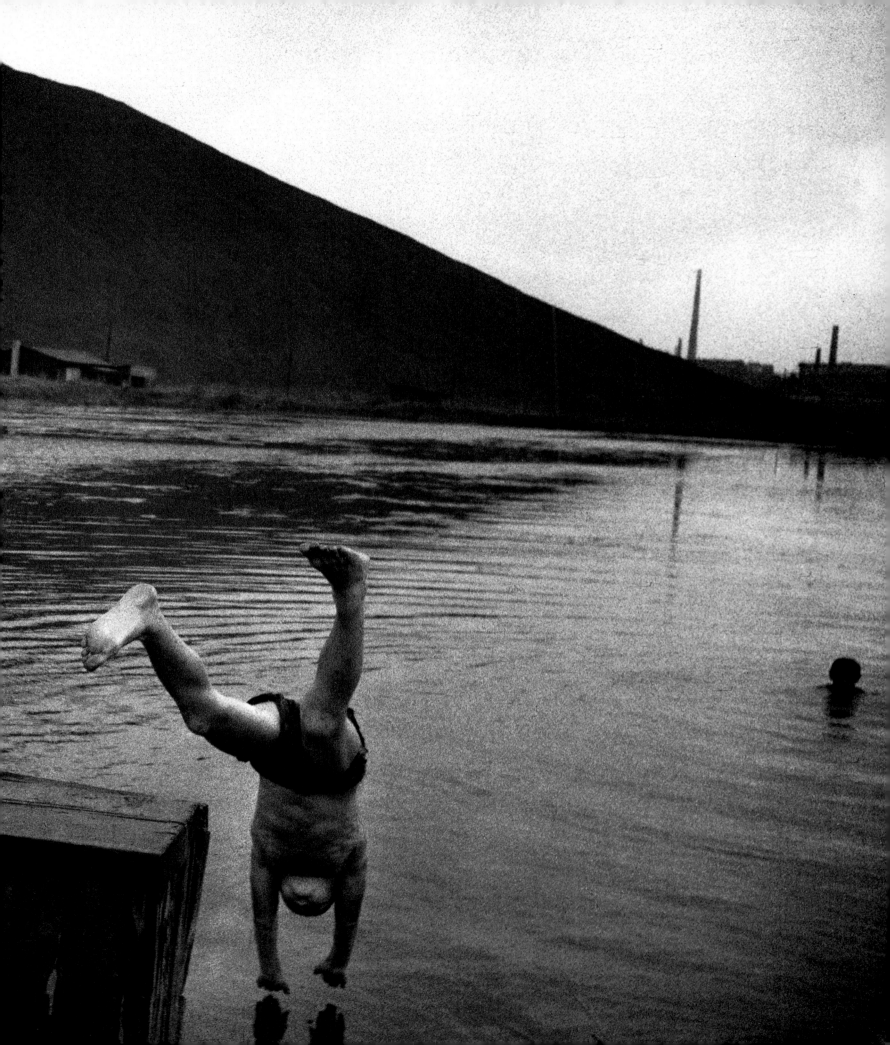

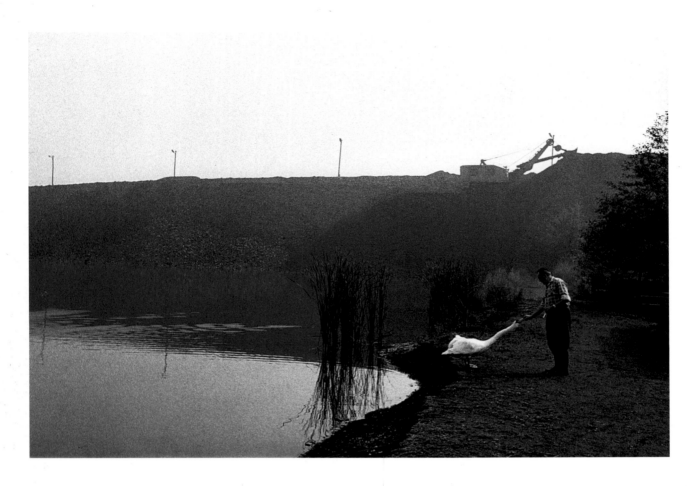

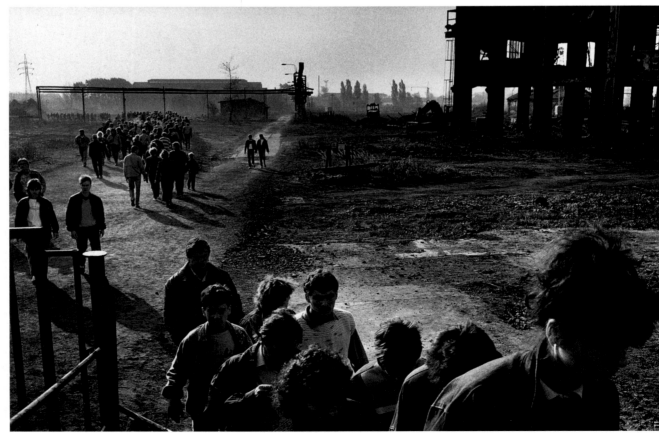

(Photographs on pages 24–25) Viktor Kolář, from the series "Ostrava," 1966–1993

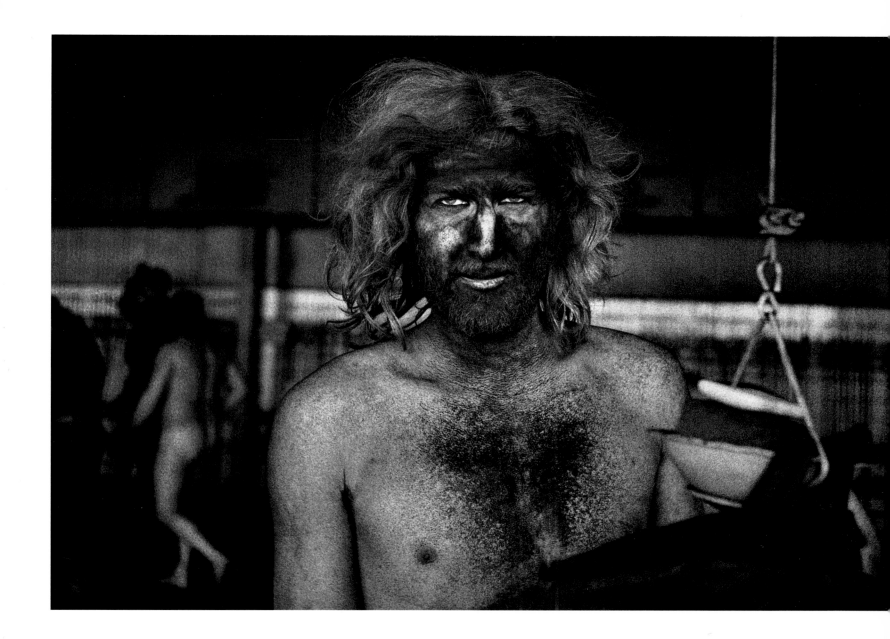

*B*eached whale, deserted ship, or Klondike gold rush town? For years, this is what Ostrava seemed to me. Its slag heaps, the night sky glowing red as though lit by the aurora borealis. And its smells—of acrid ozone following a storm, of pungent smoke from the coking plants. Especially its sounds—of gas escaping from a blast furnace, like an approaching storm—of a pipeline exploding with the urgent crack of a jet fighter.

Here, people move in endless lines, walking the endless hallways of Ostrava's factories, descending some thousand meters to dig her coal, always ready for a day's work. The miners' eyes, permanently lined with soot, glance longingly at others free from that stigma. Gigantic hands with ragged nails clasp in greeting. At dusk, the

howling sirens call them to meet their singular fates in the comforting warmth of a neighborhood pub or their own backyards. They are happy to have a piece of land behind the house, a plot of ash-covered soil to rake, to caress into life. And to drink a bottle with their mates, if only as a pretense for a chat. "Hey, old man, tomorrow again we'll dig our teeth into those kilometers of coal."

Ostrava is not a place of impressive prospects, but of high intensity. Only stop and look at the real cinema of life: tough, not very colorful, but true. Amid the black and shining coal, everything is different. Even its humor, inflected with idiom from neighboring lands, is not quite understood elsewhere.

—VIKTOR KOLÁŘ, Ostrava, 1986

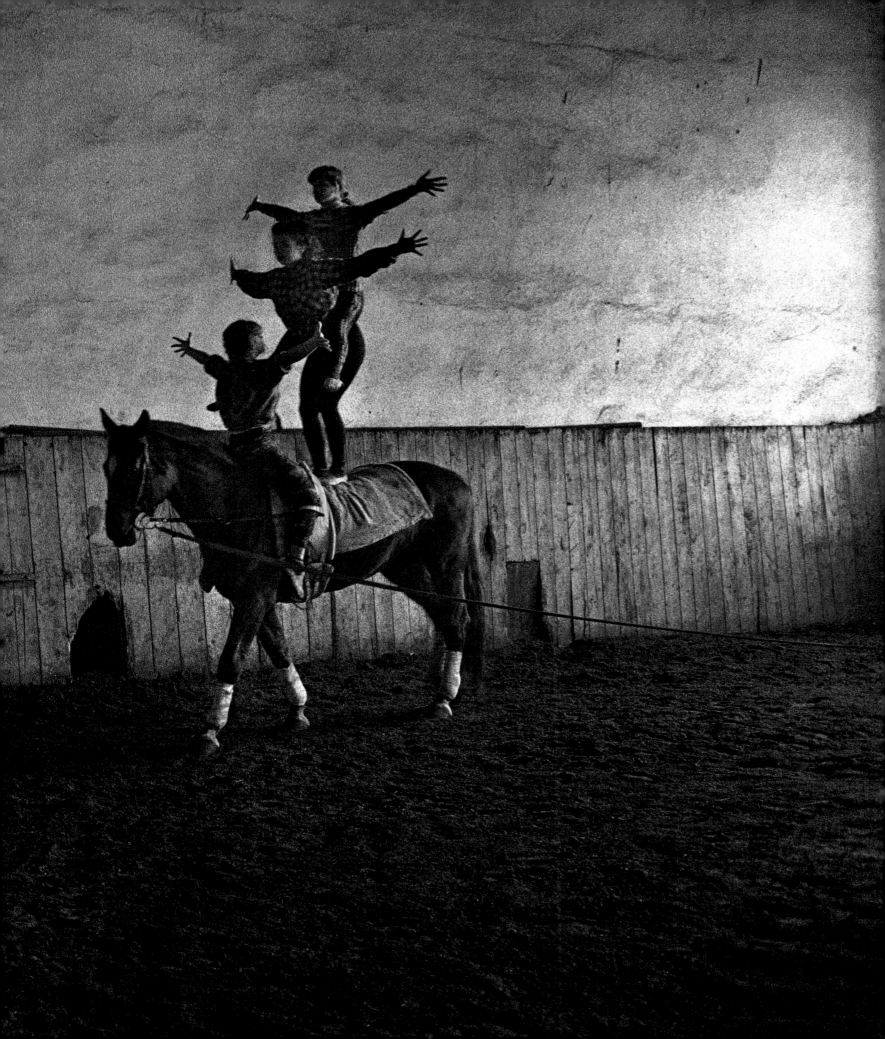

CZECH AND SLOVAK PHOTOGRAPHY:
A HISTORY OF THE PRESENT

BY ANTONÍN DUFEK

The history of Czech and Slovak photography has always offered established standards by which to evaluate new works. In spite of many unfavorable conditions in the past, the former Czechoslovakia has enjoyed a wealth of creativity that has resisted stagnation. In the postmodern era, the aesthetic imperatives of modernism have fallen by the wayside and, with the "Velvet Revolution" of 1989, social taboos in place under communism were largely discarded. The coexistence of so many diverse fields of creativity encourages persistent questioning of the meaning of artistic freedom, which has finally been joined by political freedom.

The Czech photographers best known outside of the Czech Republic today are František Drtikol (1883–1961), Josef Sudek (1896–1976), and Josef Koudelka (b. 1938). Many other names, however, are known in photography circles, among them Jaromír Funke (1896–1945) and Jaroslav Rössler (1902–1990), who are widely recognized as pioneers of the avant-garde,[1] while Czech documentary and art photographers of the '80s and '90s are attracting more and more attention abroad.

The tradition of artistic individualism is rooted in the international environment of pre–World War I Austria-Hungary. The Czech lands (Bohemia, Moravia, and part of Silesia) were the more developed part of the empire, both culturally and industrially, and a great many well-known art photographers, then as now, were of Czech origin. Some made the cultural center of Prague their home, while others achieved recognition in Vienna, the monarchy's capital, and in Dresden as well. Among the Viennese Czech photographers were Josef A. Trčka-Antios, creator of the celebrated Egon Schiele portraits (made around 1914), and Hans Watzek (a member of the Wiener Camera Club, whose influence was felt in America through its connection with Alfred Stieglitz and the photo secession movement).

Owing to its location in the heart of Europe, Czechoslovakia was a crossroads for ideas and cultural movements. Photography groups flourished, shearing new impulses of their extremes and combining them into new forms. In the early 1920s, the avant-garde stepped onto the scene and never really left, playing an equally important role in photography, the plastic arts, theater, the illustrated press, and advertising.

While Europeanness characterized camera arts in the new state of Czechoslovakia after World War I, photographers also worked to make their homeland more visible. International photographic salons were a means to this end. Helping them in this was Dragomír Josef Růžička, a New York City doctor of Czech origin who had visited Czechoslovakia since 1921 and who, as an experienced amateur, was a pupil of Clarence H. White and a member of the Pictorial Photographers of America.[2] Thanks to Růžička's efforts,

a new school which was an offshoot of American pictorialism arose in Czechoslovakia. In the early 1920s, Jan Lauschmann, Josef Sudek, and Adolf Schneeberger, among others, followed in the footsteps of Alfred Stieglitz, Gertrude Käsebier, Clarence H. White, and their colleagues.

After decades during which the trend for manipulated prints in the art nouveau style reigned, Czechoslovakia became the first European country to adopt late pictorialism. Soon, however, this relatively progressive style began to take on a uniform, optically programmed feeling, and finally it was eclipsed by more dynamic forms of expression. By 1930, all the supporters of that school (including Růžička) had adopted Neue Sachlichkeit, or "new objectivity." This was a natural progression, since Czech photographers frequently exhibited their work abroad, and there was a constant flow of ideas among artists in Europe and America. The "new objectivity," which upheld qualities specific to the medium, served as the mainstay of Czech photography through the '20s and '30s.

Only a few of the Czech participants in the international photo salons of the early '20s (namely, Jaromír Funke, Jaroslav Rössler, and occasionally František Drtikol) adopted cubism. Drtikol was molding a synthesis of the art nouveau and cubist vocabularies into an art deco form whose influence can still be felt today, while Funke developed an abstract photography based on photogenism, and Rössler adopted constructivism. By the 1920s, photography had already escaped its dependence on traditional media.[3]

Between the wars, Czechoslovakia soon became the last mainstay of democracy in Central Europe, as nondemocratic regimes seized power on every side of the young state. While the avant-garde was suppressed by force in neighboring countries, Czech and Slovak photographers were unrivaled in terms of output; they belong among the elite of the new objectivity, with Ladislav E. Berka, Alexander Hackenschmied, and Eugen Wiškovský at the forefront.

Surrealism has enjoyed a particularly strong standing in Czechoslovakia over the years. The importance of surrealism for photography, and vice versa, was nowhere more apparent than in early avant-garde circles there. Among those who devoted themselves to the search for surreality in reality were Jaromír Funke, Jindřich Štyrský, and Vilém Reichmann.[4] Working in secret, surrealist Czech photographers endured World War II and later the Stalinist suppression of the '50s. The Prague group exists to this day, under the leadership of Jan Švankmajer, the world-renowned experimental filmmaker and animator. Surrealism's greatest contribution, perhaps, has been to serve as inspiration for a freer interpretation of reality.[5]

The years from 1938 to 1958 were depressing ones: the Nazi occupation, followed by a short breather after the war, then

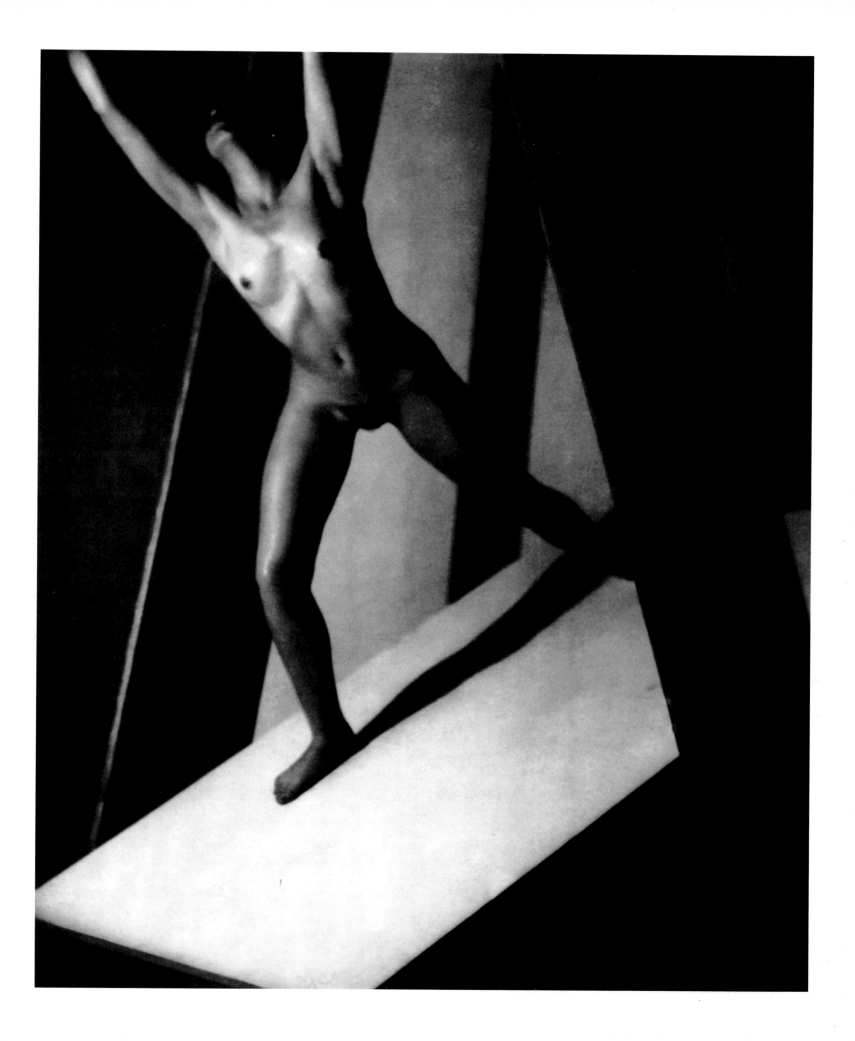

Soviet occupation and the Iron Curtain marking the divide between democracy and totalitarian rule. In the mind of the authorities, photography's only purpose was for propaganda. Art and culture were split between the official and the unofficial. During and after the war, such documentarians as Jan Lukas, Karel Ludwig, and Jindřich Marco began creating their most important work, and a new phase began in the work of "the quiet heretic" Josef Sudek, the Czech predecessor of postmodernism.

Following the death of both Stalin and Czechoslovakia's first Communist president, Klement Gottwald, in 1953, the state gradually began to loosen its grip on culture. Around 1958, creative photography was recognized as an art; permanent exhibition spaces for photography were established; reviews were published; and the Art Photography Press in Prague brought out the first monographs on such masters as Henri Cartier-Bresson, Paul Strand, Brassaï, László Moholy-Nagy, and André Kertész.

It now seemed that the art world was impossible to divide. Photographers on both sides of the Iron Curtain picked up where the prewar avant-garde had left off and found themselves through new currents, both ideological (existentialism) and artistic (abstract art, new figuration). East of the Iron Curtain, the term subjective photography was not allowed because objectivism and collectivism were the officially recognized styles. This gave rise to the term creative photography. All kinds of approaches fit under this heading, including street photography and photojournalism.

Perhaps the most quintessential Czech trend that took hold in the late '50s was an interest in the uneverydayness of the everyday, a lyrical and aesthetic interpretation of the ordinary, the "pearls on the bottom" as the celebrated writer Bohumil Hrabal entitled one of his short story collections. Here the values of everyday life contrasted with the bombastic ideology of socialist utopia. As time passed, photographers diverged from the poetry of the everyday and began to take a greater interest in the flip side of civilization (the so-called trash culture) and in purely visual subjects and their depiction. Around 1970, the existentialist photographer Jan Svoboda developed his personal version of minimalism.

In the relaxed political atmosphere of the late '60s (which ended with the Soviet occupation of Czechoslovakia in 1968), a new style appeared: staged photography (known as "set-up" photography), born out of the new generation's rejection of "creative photography," whose values had been exhausted and which was drifting into tilted aestheticism and formalism. The so-called new wave photographers (Jan Saudek, for example) championed content, expression, symbolism, and romanticism. In its ideas, the new wave was a unique variation on the hippie movement, resonating (most of the time unwittingly) with happenings, body art, and performance art. Paralleling the new wave in Czech cinema as conceived by Věra Chytilová, Miloš Forman, and Ivan Passer, set-up photography was also greatly influenced by the films of Michelangelo Antonioni.

Unable to sustain its narrow confines, set-up photography gradually degenerated into mannerism, artificiality. The generation educated during the '80s at FAMU film school in Prague, however, began to work with staged and manipulated photography on a new level, reflecting the paradoxical persistence of the regime. By the middle of the decade, this genre had achieved unprecedented popularity, both at home and abroad, with its inventive experimentation; its sense of the absurd, the grotesque, the comical; its subtle eroticism, which smashed prior taboos. Yet its affiliation with tradition (through Drtikol and Zykmund) was also important. The 1986 series of triptychs titled *Game for Four* (p. 41), by Michal Pacina, Rudo Prekop, and Tono Stano, served as a declaration of sorts for the movement. Among the many outstanding makers of staged photography whose work is included in this issue of *Aperture* are the Slovak photographers Vasil Stanko, Pavel Pecha, Kamil Varga, and Peter Župník.

Following the "Velvet Revolution" of 1989, a significant shift took place: the Moravian group called the Brotherhood, spearheaded by Václav Jirásek, contributed a new postmodern style. Taking their cue from Josef Sudek, these artists proceeded to quote the history of art, from the romanticism of the last century to the socialist realism of the '50s. And in this publication, Ivan Pinkava recalls the late nineteenth century through decadent portraits reminiscent of the French photographer Nadar, while Pavel Mára and Jan Pohribný approach the context of today's multimedia art.

Documentary form plays an important role in Czech culture today, particularly in the cinema. Yet from the '30s until the late '70s, knowledge of works by American and European documentarians was minimal. The break came along with the Prague Spring of 1968, when restrictions were briefly lifted: Josef Koudelka's *Gypsies* was a revelation; the *Pilgrims* of Markéta Luskačová (now living in London) and the works of Viktor Kolář, Pavel Štecha, Dagmar Hochová, Mílón Novotný, and others had a similar impact. Although it was impossible to publish truthful news photos in occupied Czechoslovakia, social documentary photography virtually became a mass movement during the period of "normalization" imposed by the Soviets during the '70s and '80s.

The documentarians first found their home in a Prague theater called Činoherní Klub. During the trying years from 1978 to 1981, under the patronage of historian Anna Fárová, eighteen photographers, most of whom had graduated from Prague's FAMU film school, showed their work there. In 1981, the group organized a monumental exhibition in the ravaged Plasy monastery. Everyone involved sacrificed a great deal of time, energy, and money for the show, which also put them at risk politically. Jindřich Štreit was later imprisoned for his photographs (which were viewed by the authorities as antipropagandist), but since 1989 he has produced a dozen projects, most of them in book form. Members of this circle whose work can be seen in these pages are Bohdan Holomíček, Viktor Kolář (winner of the *Mother Jones* Prize in 1991), and the trio of Ivan Lutterer, Jan Malý, and Jiří Poláček.

As this century draws to a close, a great sense of hopefulness, experimentation, and international collaboration, echoing the *fin de siècle* mood of the last century, permeates Czech and Slovak photography. One can hardly grasp its exceptional achievement without some knowledge of the past, of tradition.

Translated from the Czech by Alex Zucker

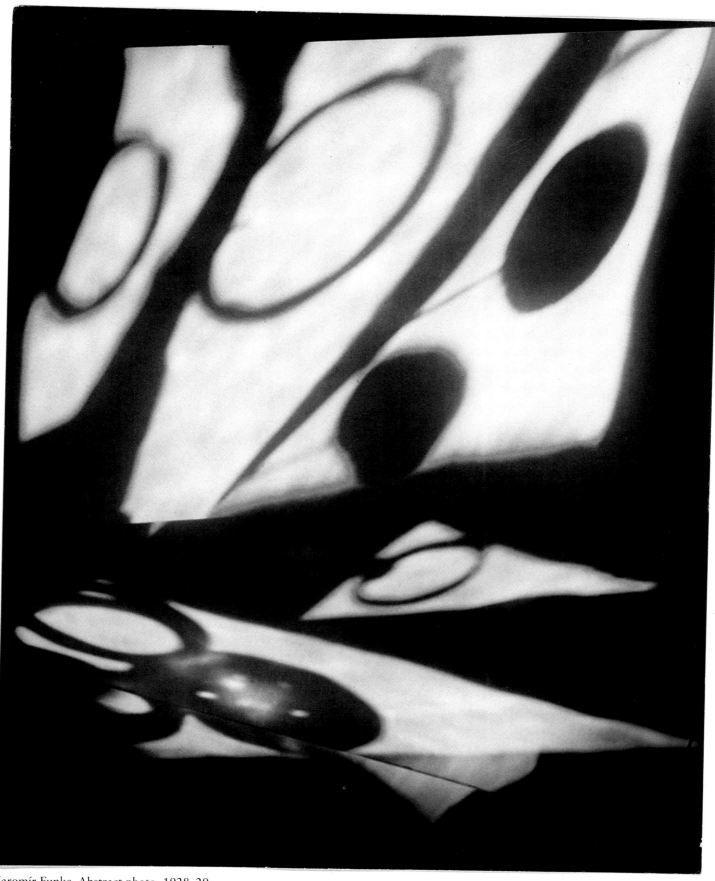

Jaromír Funke, Abstract photo, 1928–29

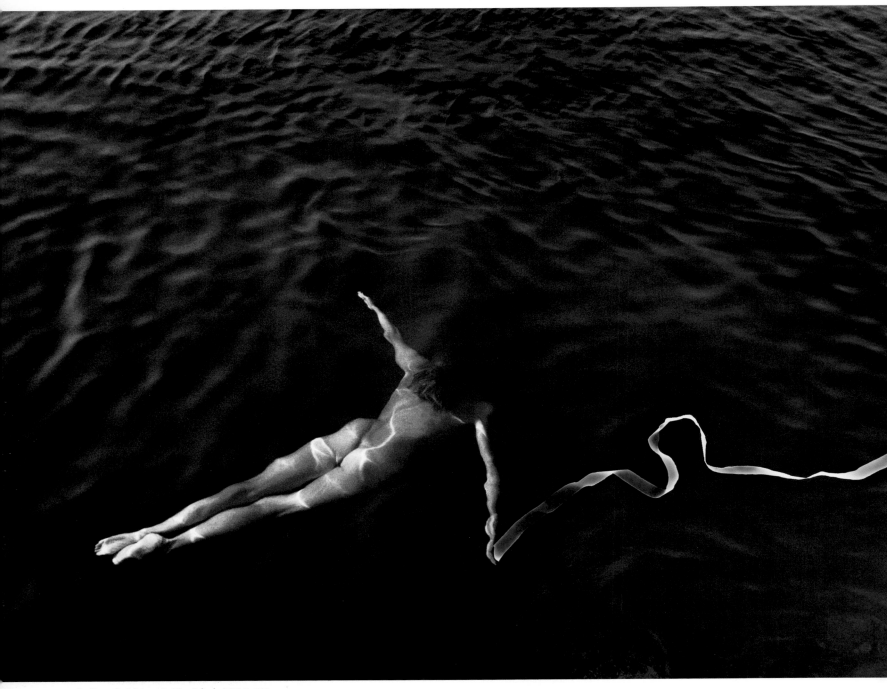

Judita Csáderová, *Untitled*, 1966–97

BETWEEN TWO WORLDS

I rise from the sea,
salt washing off of me
until the day I die.
I emerge from the waves,
rocks underfoot,
an overgrown garden
sprouting on the bottom.

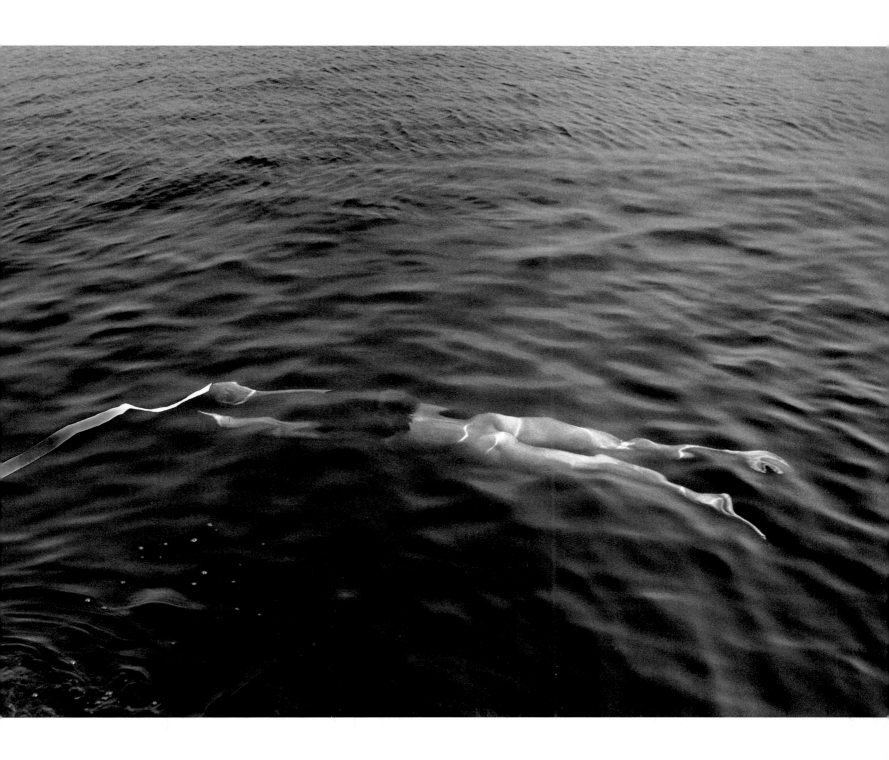

Still it holds onto me,
scraping hurtful scales
from my flanks,
casting forth fish, my sad sisters,
as it curses me, black from
the waist up. I surface,
like Ondine but branded,

songless. Ready
for neither life nor death.
And the sea will never take me back
alive.
—ANNA ONDREJKOVÁ, 1996

Translated from the Slovak by Alex Zucker

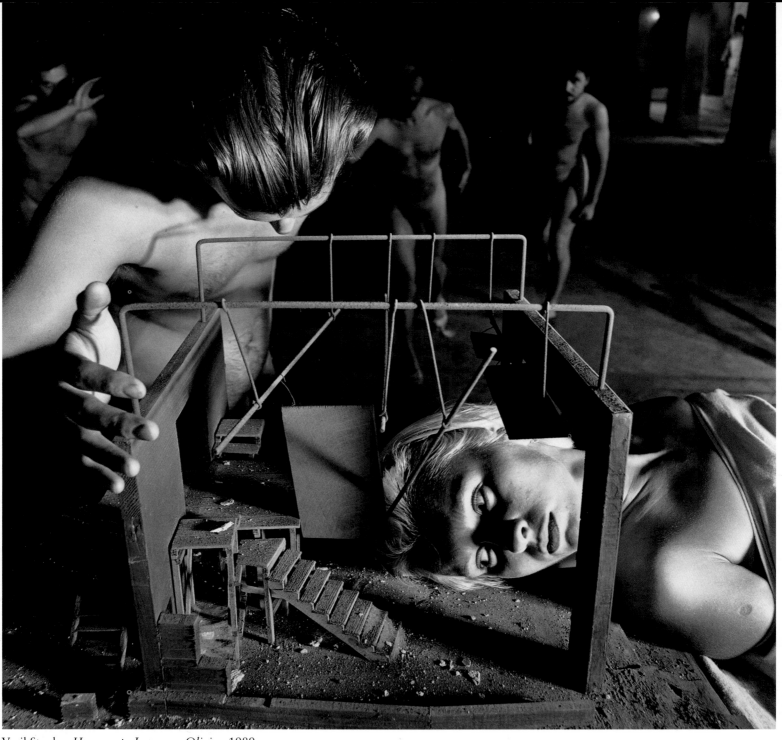

Vasil Stanko, *Homage to Laurence Olivier*, 1989

TEMPLE OF UNREST

*I*maginary spaces, human body shrines, illuminate Vasil Stanko's world of ideas. To interpret motion and gesture in photographs, to choreograph figures into exacting compositions, resides in the artist's imagination. This allows him to create architectural elements using the human figure to define space. Through his distinctive use of perspective scale, the figures not only define those spaces, they become architecture: caryatids or gates, natural or artificial temples. The figures are enveloped by darkness; light glides over their contours, emphasizing form. Between the front and the rear of the picture's space is a gaping emptiness. There

Opposite: Vasil Stanko, from the series "How to Take Care of the Natives," 1991

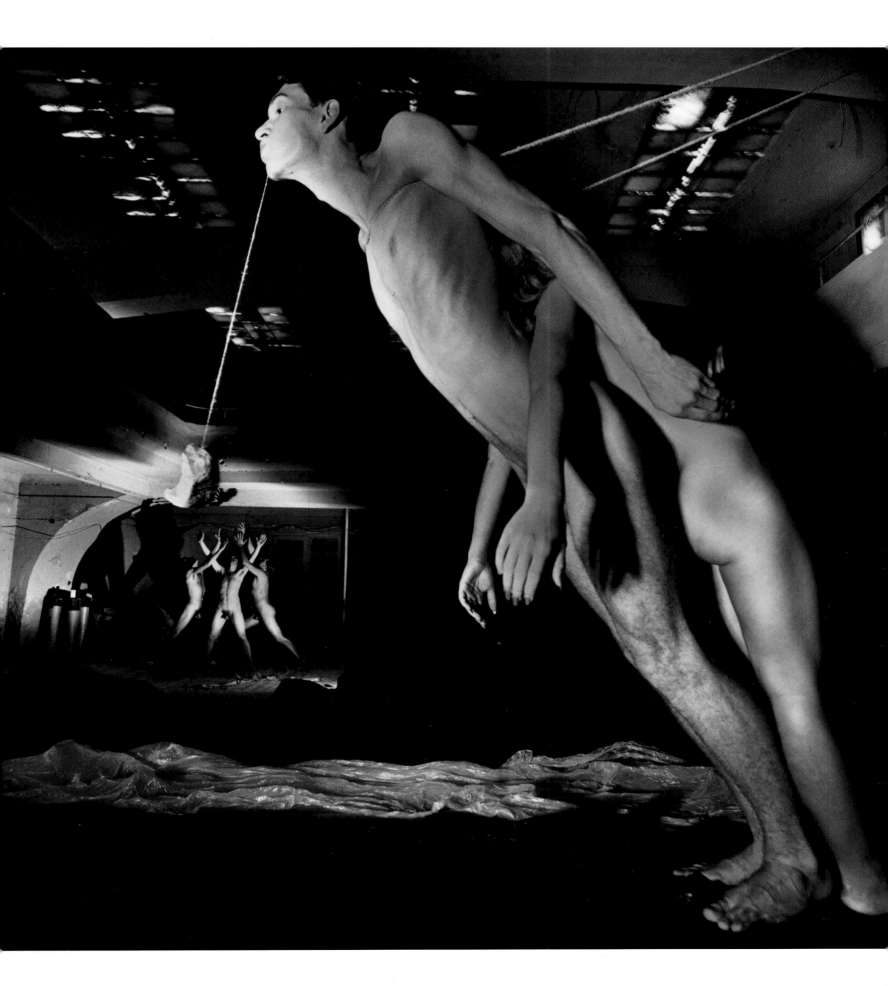

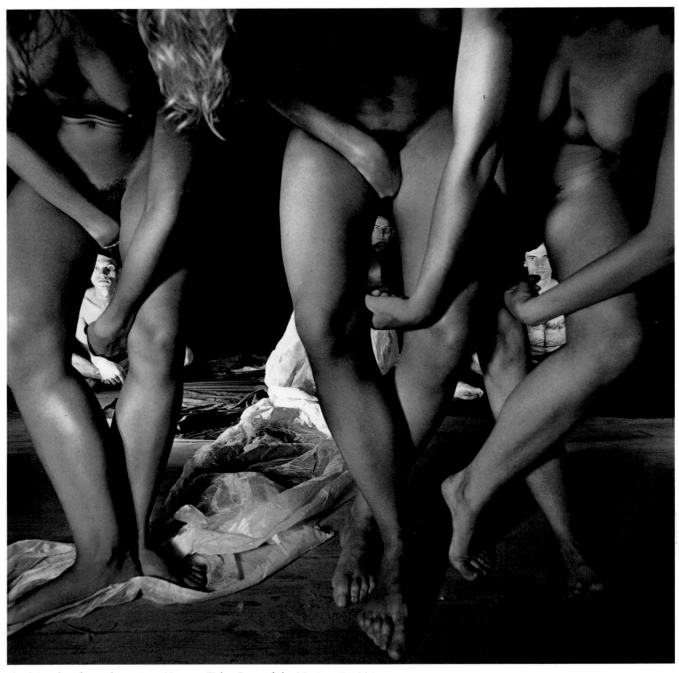

Vasil Stanko, from the series "How to Take Care of the Natives," 1991

he builds an interspace that can be read as primordial matter before creation, an undefined zone where the soul and the mind can evolve. The bodies' nakedness expresses natural order, pure humanity, neither provocative nor inviting. The laws of Nature are expressed through movement. The figures are often frozen in a jump, which dynamically represents noise. Still figures, static and solid, manifest silence. Upward movements with a hovering tendency, together with figures lying heavily on the floor, express the elemental laws of gravity. The psychodramas of little societies reflect the disquietude of the great society of the world. In this realm, the choreography, shared by the participants in its staging, acquires the sense of ritual.
—Adapted from a text by Anna Fárová

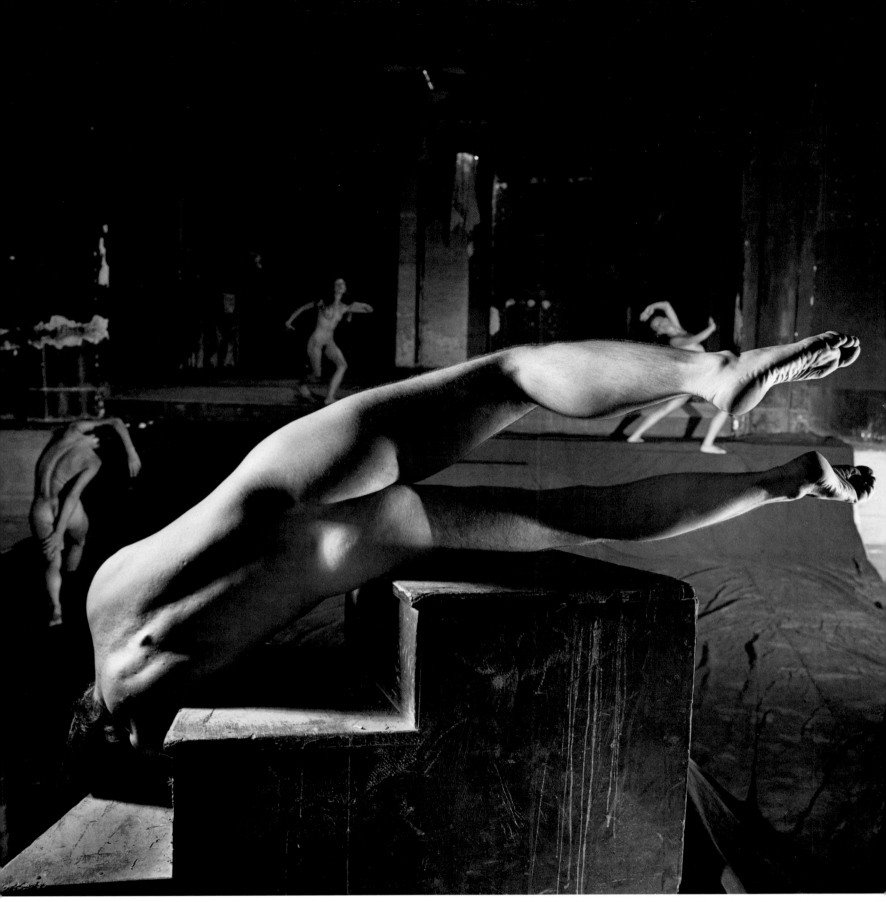

Vasil Stanko, *Stroke*, 1994, from the series "What is it?"

REALITY IMPRINTS

*I*t is said that the photograph is an existential imprint of reality. Eadweard Muybridge's photographs are the imprints of real horses. My photographs are the impressions of their hooves.
—PAVEL MÁRA

Pavel Mára, installation view of
series "Imprints—Veils," 1989

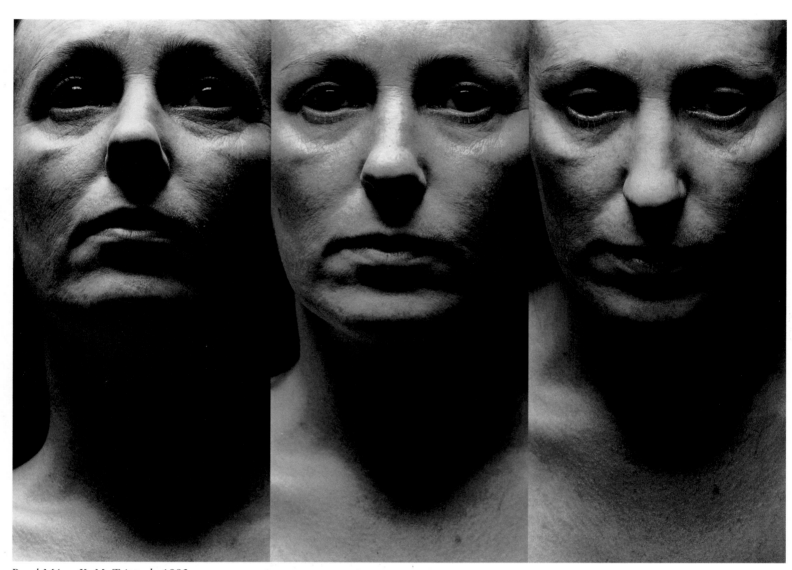

Pavel Mára, *K. M. Triptych*, 1993

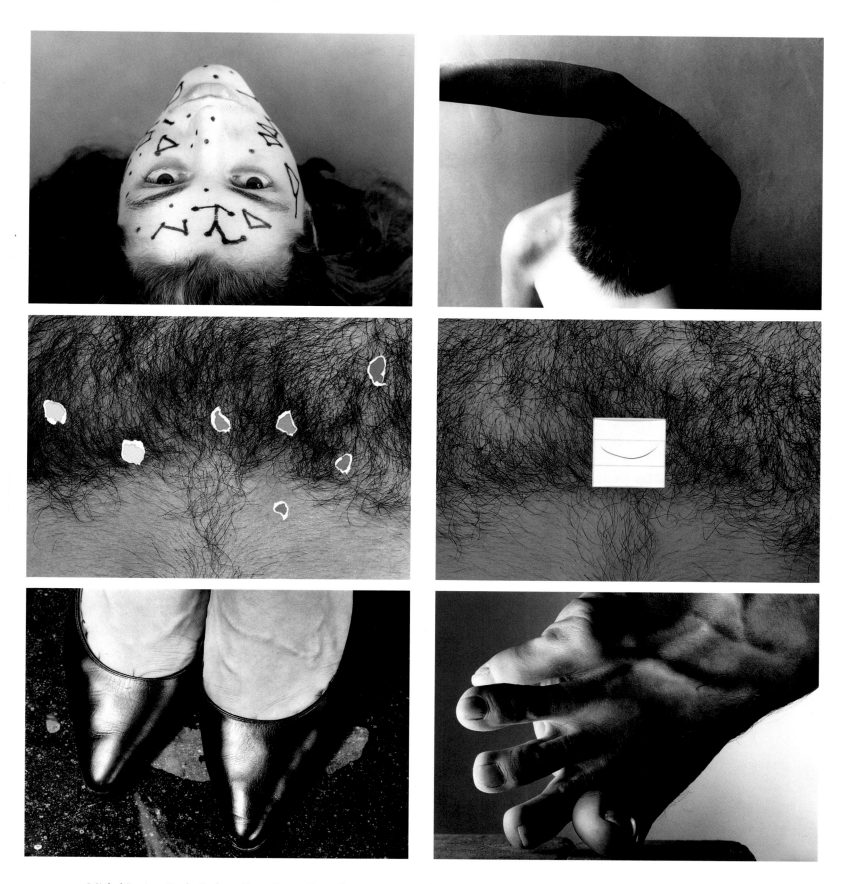

Michel Pacina, Rudo Prekop, Tono Stano, from the series "Game for Four," 1986. The title of this series is a play on perceptions in which the three artists collaborated. Unlike the surrealist invention "Exquisite Corpse" (usually played privately by a group of artists or writers), "Game for Four" is a public diversion. Here the viewer, as interpreter of characters in the triptychs, becomes a fourth player.

*I*n a series of nudes that he began in the 1980s, Tono Stano explores the irreality of the camera—its capacity to obscure the obvious while revealing the fundamental, in obsessive detail. Theatrical lighting, which imposes a graphic quality on a female torso, likewise banishes the notion of what beauty-product advertisers might call "satin-smooth" skin.

Under communist rule, when eroticism in art was suppressed, photographing the nude was most often done in secret, or, if overtly, as a form of protest that was severely reprimanded. Stano's images, however, openly created and widely exhibited, circumvented official criticism. Even in photographs of genitalia, his nudes could not be construed as antipropagandist.

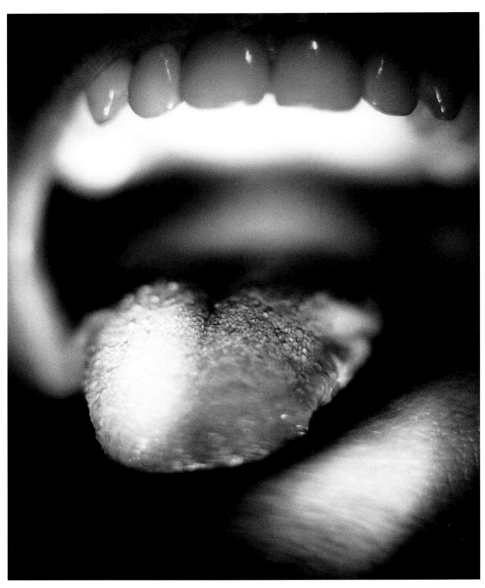

Tono Stano, *A Partially Illuminated Way*, No. 2, 1996

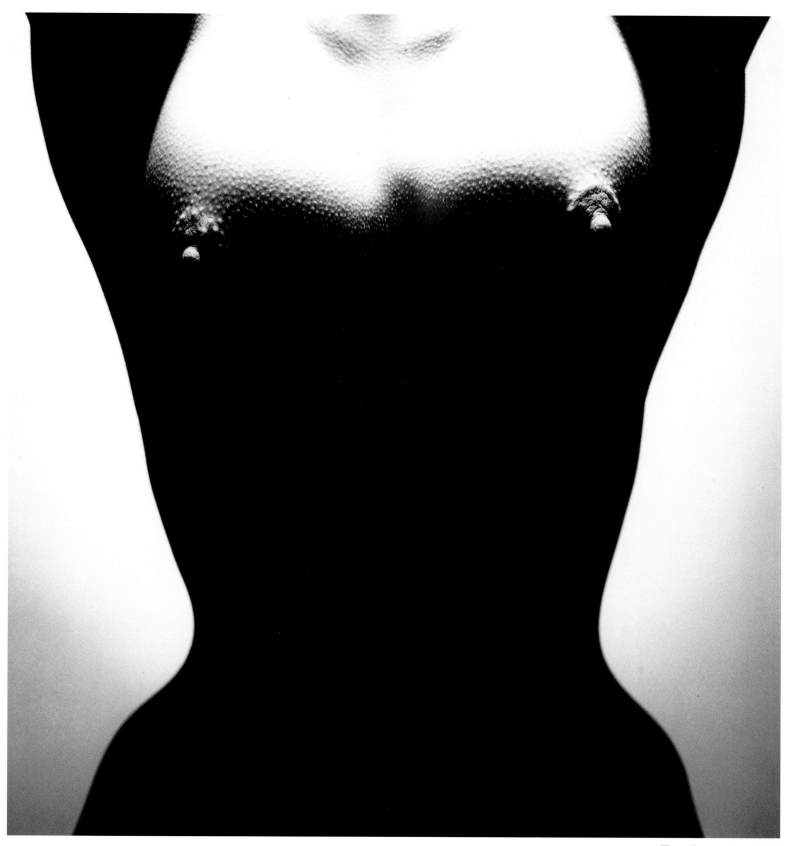

Tono Stano, *Top*, 1994

THEATER OF IDENTITY

Why are we here, we ask in a dream.
Why were we here, we ask awake.
Why shall we remain here, when we are no more?
 —VLADIMÍR HOLAN, from *Mozartiana*

For more than a decade, Ivan Pinkava has made portraits whose austere elegance has strong affinities with certain nineteenth-century portraits, in particular those by the French photographer Nadar. Like Nadar, Pinkava's interest is focused on the figure, starkly alone. His pictures are pared down, all extraneous detail banished in order to transmit a sense of unified mental and physical condition. Yet Pinkava's subjects continually frustrate our efforts to place them culturally, historically, or otherwise. These faces bear the marks of timeless conflict, scarred, heavy-lidded, emotionally frayed. They are hardened yet also vulnerable and tender. They appear to us as deprived outsiders burned by excess, refugees who have gained temporary sanctuary in Pinkava's imagination.

Among Pinkava's early portraits are a series dedicated to such pillars of European modernism as Artaud, Mayakovsky, Nietzsche, and Dostoyevsky. In a sense, all of his subsequent work makes reference to a modernist legacy of alienated expression. Yet Pinkava deliberately places his subjects on the brink of overstatement. He refers to these figures as both "holy" and "foolish"; it is tempting to read them as victims of an ideology or belief system that has run aground. Pinkava, however, sees them as adrift, as "beings from the end of the century . . . beings of the universe: sexless, disowned, expressive."
 —*Adapted from a text by David Chandler, 1993*

Passion, romance, emotion have been banished to the margins of our world. We seek the silenced, flip side of the present, where man finds himself a sinner, faced with God and the nakedness of his own body. Surrendered in ecstasy, appealing for mercy, he clings to the irrevocable hope that man's erotic, corporeal nature is not yet lost. From the union of light and dark, day and night, he emerges reborn, still downy, free, and without equal.
 —*Adapted from a text by Věra Jirousová*
 Translated from the Czech by Alex Zucker

Opposite: Ivan Pinkava, *Dynasty No. 10*, 1991; *page 46:* Ivan Pinkava, *Salome*, 1996; *page 47:* Ivan Pinkava, *His First Wine*, 1996

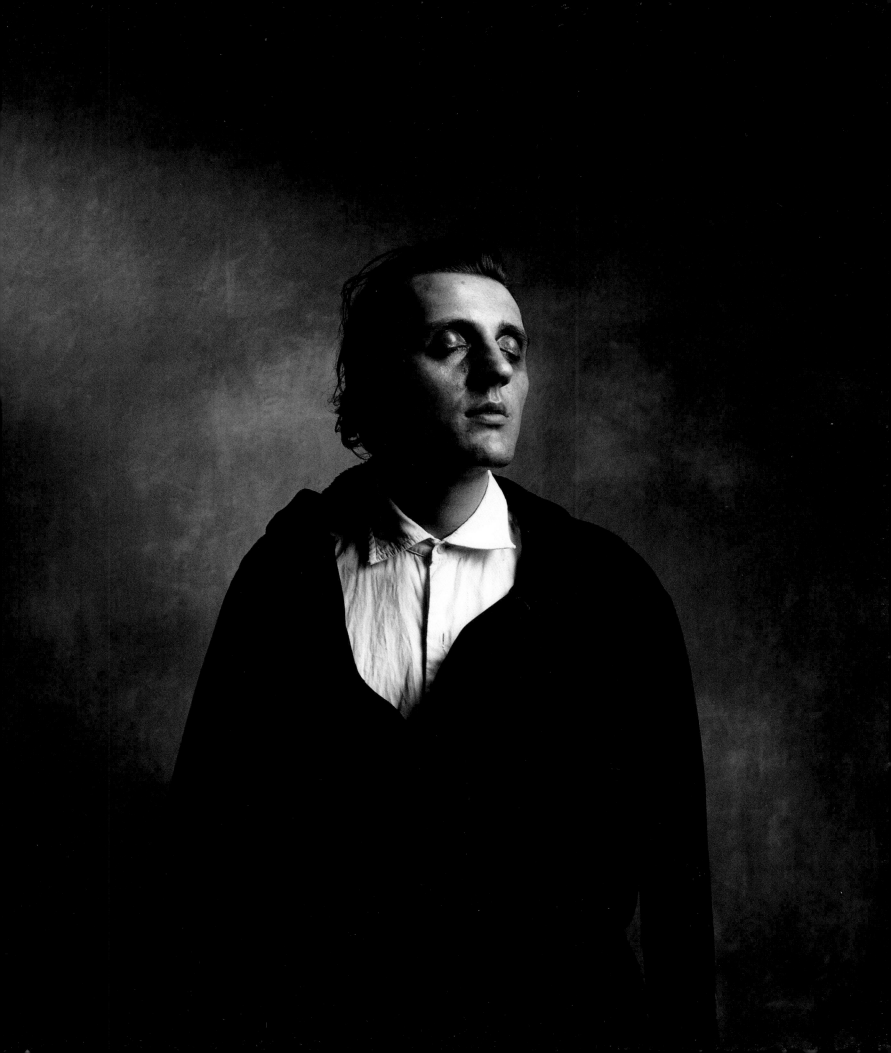

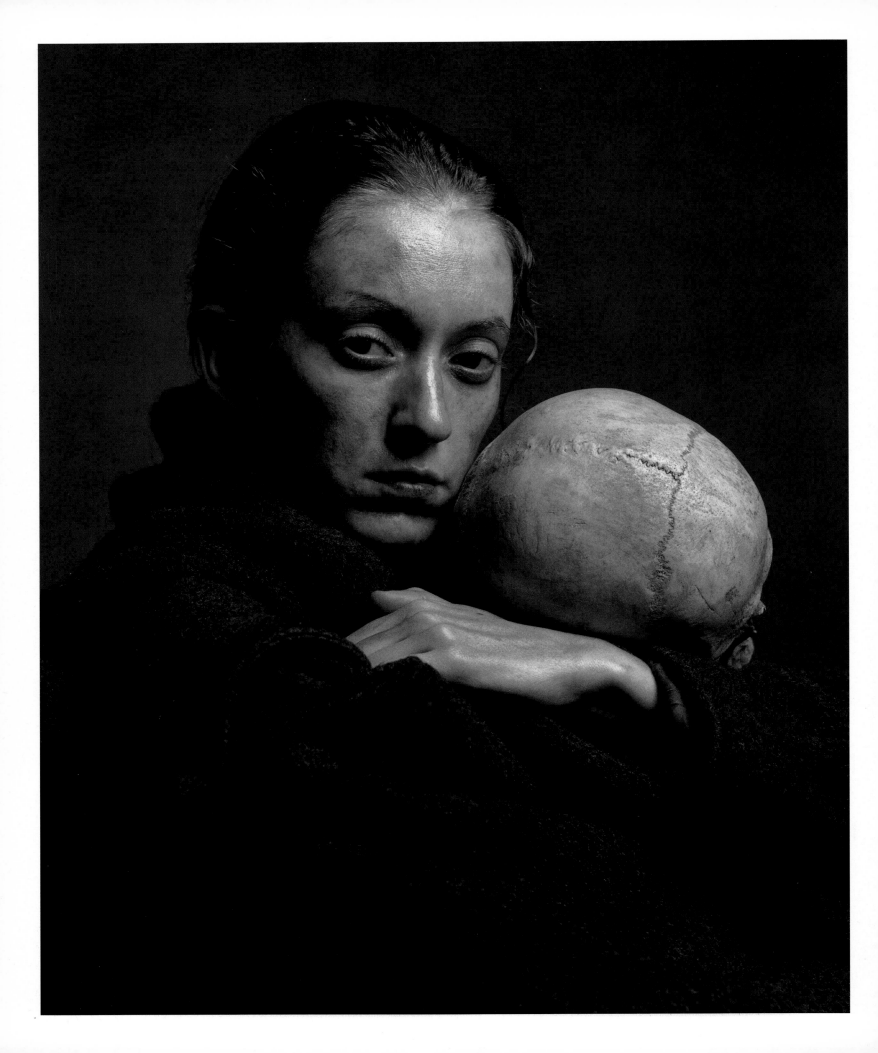

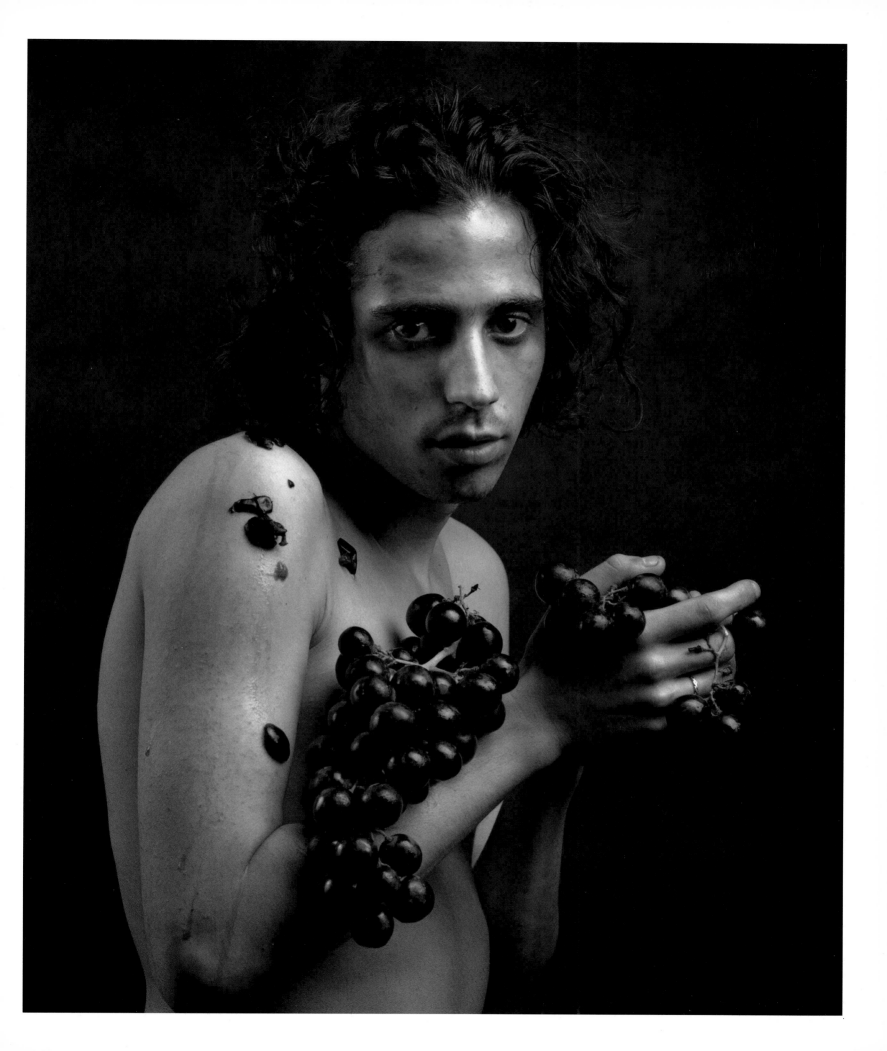

MY SKULL'S SHADOW

THE WORLD THAT I LIVE IN DOES NOT EXIST.
Similarly all the chores on my list.
To rely just on sight—what a mistake!
The mirror goes blind, the quicksilver flakes,
And just as my image is merely a figment,
I too am a mirage, before and behind it.
 —J.H. KRCHOVSKÝ
Translated from the Czech by Alex Zucker

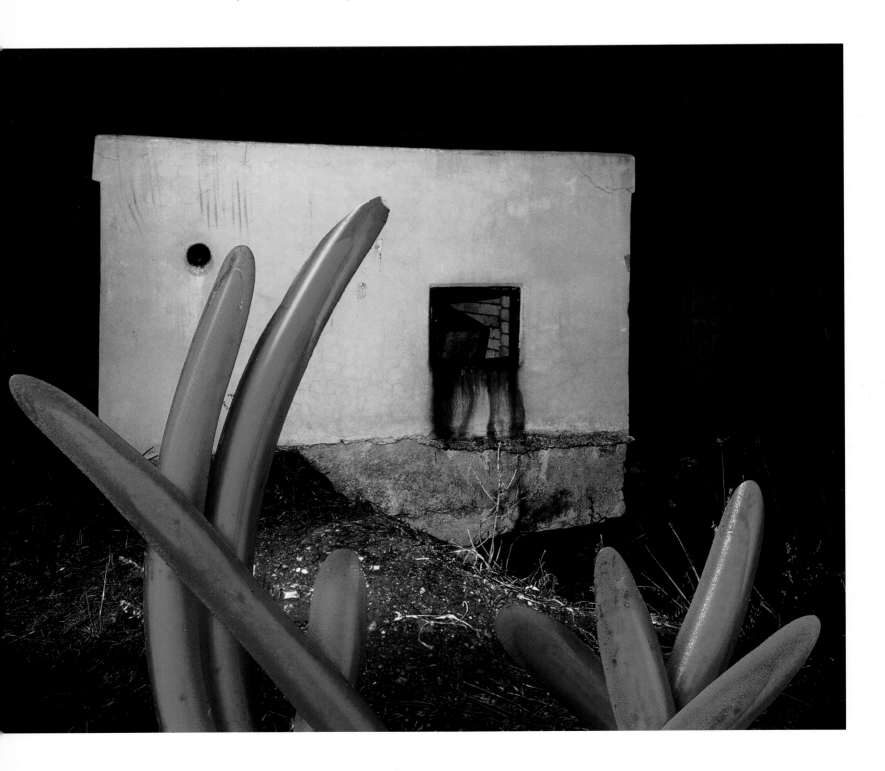

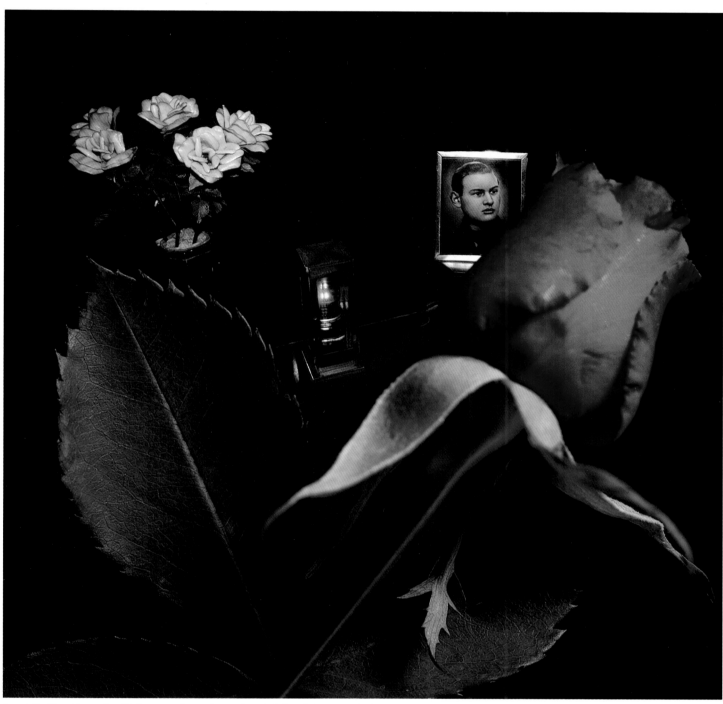

Pavel Baňka, *Rose for Unknown*, from the series "Night Visions," 1993–94
Opposite: Pavel Baňka, *Twenty-first Century*, from the series "Night Visions," 1993–94

DANCING AT
THE EDGE OF TIME

"I had a hallucination where a spiral was twirling before my eyes. A spiral—energy in motion, like a spinning chakra. A spiral—the passage into a different space."
—KAMIL VARGA

In his large-scale, expressionistic images, Kamil Varga seeks to find the preliterary essence of the world. Using the tools of photography, combining techniques of montage, multiple, and hours-long exposures, he creates a fiery realm expressing the sensuality of ritual, the wildness of barbarism, which he invites to remain for the future. In Varga's domain of light, images that never existed in the real world are given invented names, such as "Biarchia" and "Dromacyclus." As light becomes liberated from space and time, images become unnamable. Instead, they are marked by primitive signs.
—Adapted from a text by Václav Macek

Kamil Varga, *Biarchia*, from the series "Metabolism by Fire," 1996

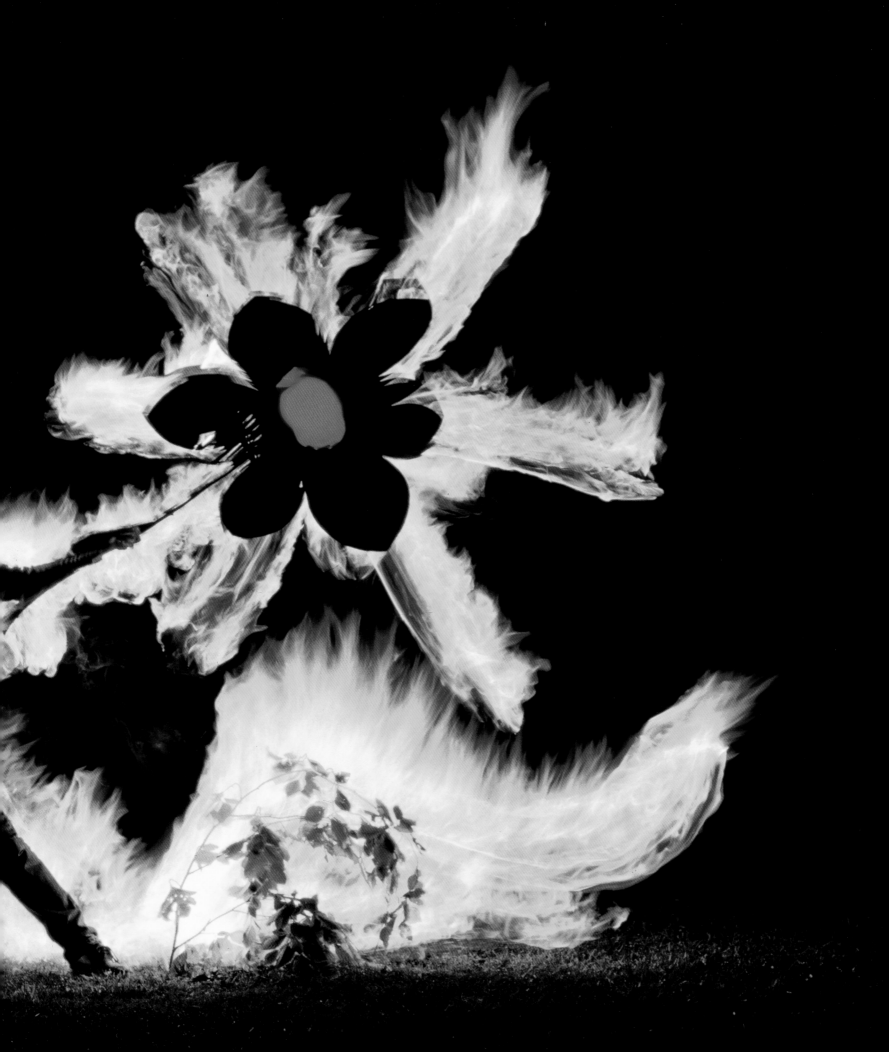

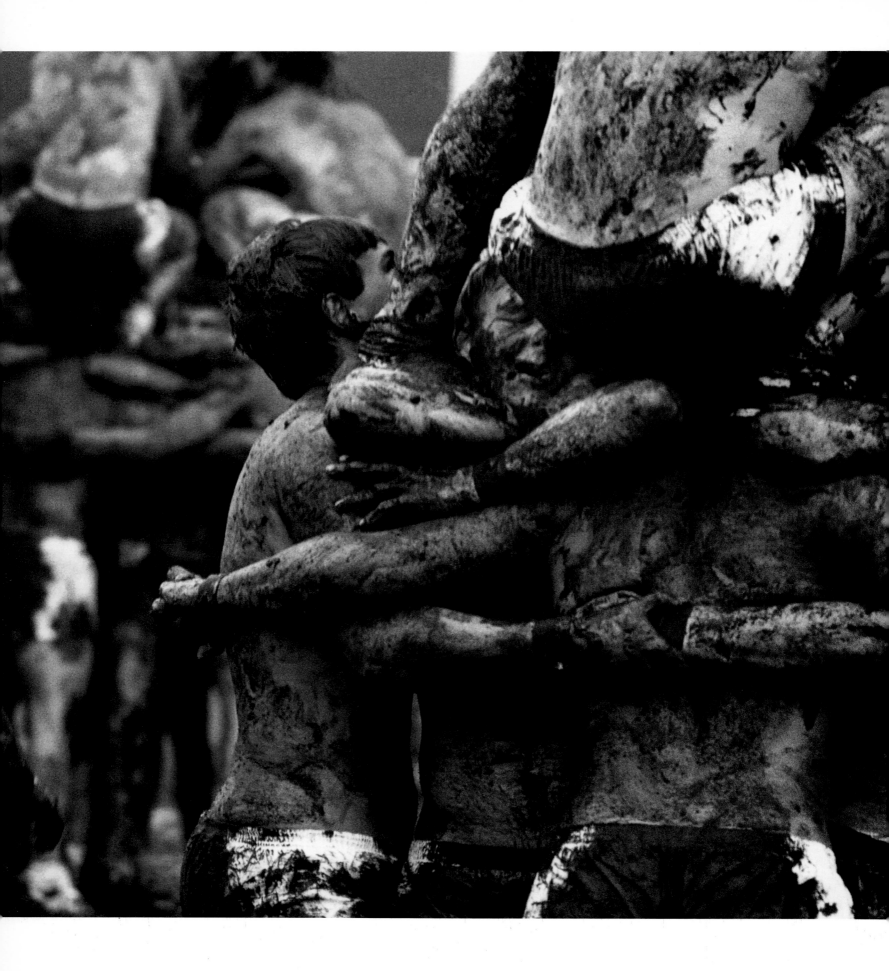

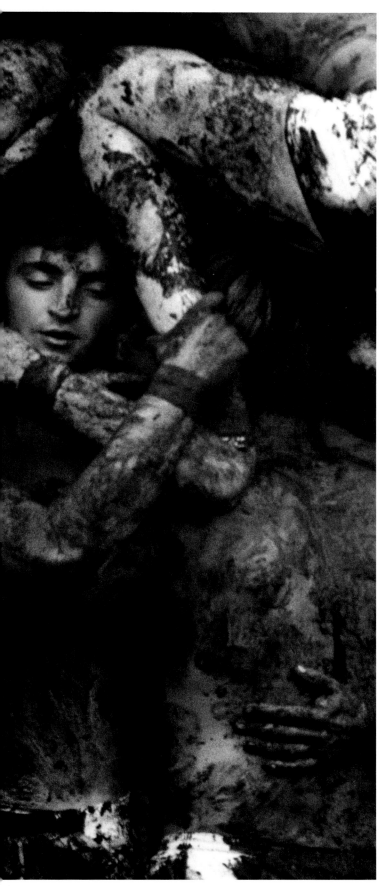

Zdeněk Lhoták, from the series "Spartakiada," 1985

MODEL SOCIETY

In May 1985, I photographed the Prague Fifth District Spartakiad on assignment, but without enthusiasm. This stadium event was staged every five years to display the glory of the communist regime through its people's strength and unity. This time, there were tens of thousands of participants, in all age groups, who were forced to take part or be punished. The foul weather and the inane bombast of party officials only heightened the feeling of absurdity surrounding the event. As the rain fell, Strahov Stadium's fresh green turf was gradually transformed into a field of black mud filled with living friezelike tableaux created by the athletes' coordinated calisthenics.

The aesthetic impression this made, however, was negated by a moral perspective from which the entire Spartakiad could be viewed as the outright manipulation of human beings. A body covered in mud is nothing objectionable. But forcing people to perform in degrading conditions, with the purpose of negating human individuality and pride, bordered on the criminal.

As I photographed, I soon began to experience a powerful feeling of exhilaration; it seemed that this was the "it" some photographers wait a lifetime for. During the young soldiers' performance, I captured faces contorted in pain, marching legs, bodies completely covered in mud, and views from above depicting the absolute symmetry of those exercises.

The result was a collection of photographs that elicited controversy from the outset. For the most part, adherents of communism viewed my series as blatant anti-propaganda. To circumvent the inevitable suppression of these images, I needed some official "seal of approval." This came in the form of first prize in "100 Best Sports Photos of the Year" (a competition sponsored by the Czechoslovak Union for Physical Fitness.) Naturally, the group of photos I submitted had to include one that set an optimistic tone. In it, one of the muddy soldiers, his arms raised high, soars above the others, toward "better tomorrows." Having served its function, that photo has never since been shown. It was a somewhat underhanded ploy, yet it enabled me to publish and exhibit the series internationally. In 1986, it received second prize in the World Press Photo competition in the sports story category.

Although these photographs have been widely seen, I still feel that the true sense of these images can be felt only by those who have had a firsthand experience of the Spartakiad as it played out under the communist regime.

—ZDENĚK LHOTÁK

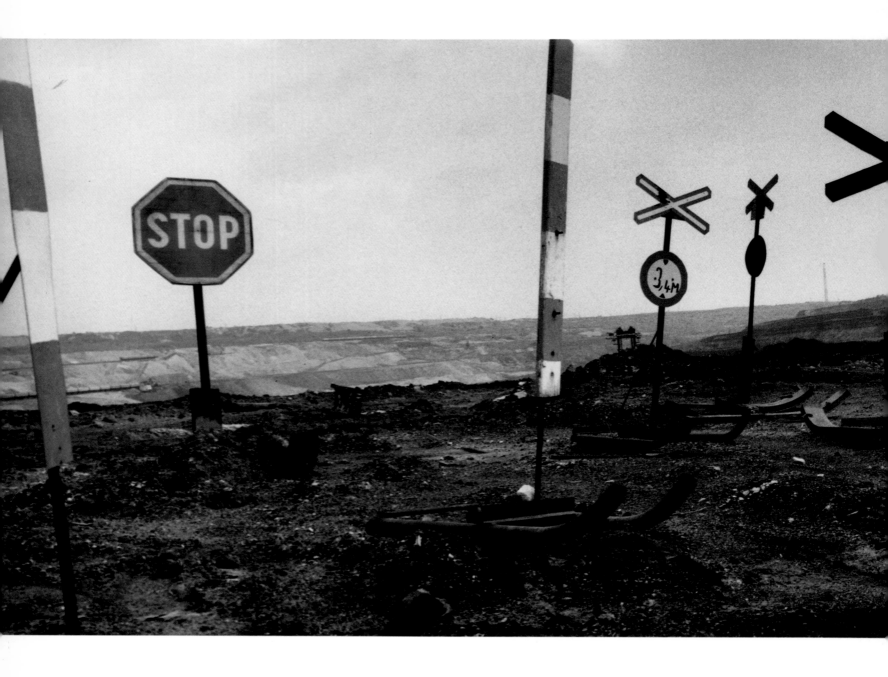

THE BLACK TRIANGLE

*I*n 1990, Josef Koudelka began photographing in a region of what is now the Czech Republic where the land and *its towns and villages have been devastated by open-pit coal mining and industry. Thirty-four panoramic photographs from his study, along with a text by Josef Vavroušek, former Minister of the Environment, were published as an accordion-fold book entitled* The Black Triangle—The Foothills of the Ore Mountains *(Prague: Vesmir, 1994).*

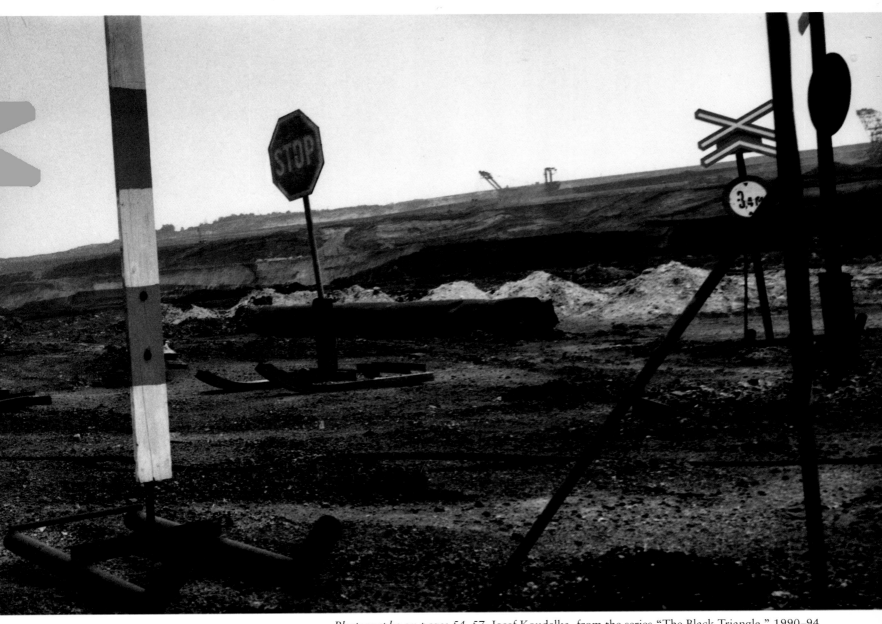

Photographs on pages 54–57: Josef Koudelka, from the series "The Black Triangle," 1990–94

Peter Župník,
Kafka in Prague,
1985–91

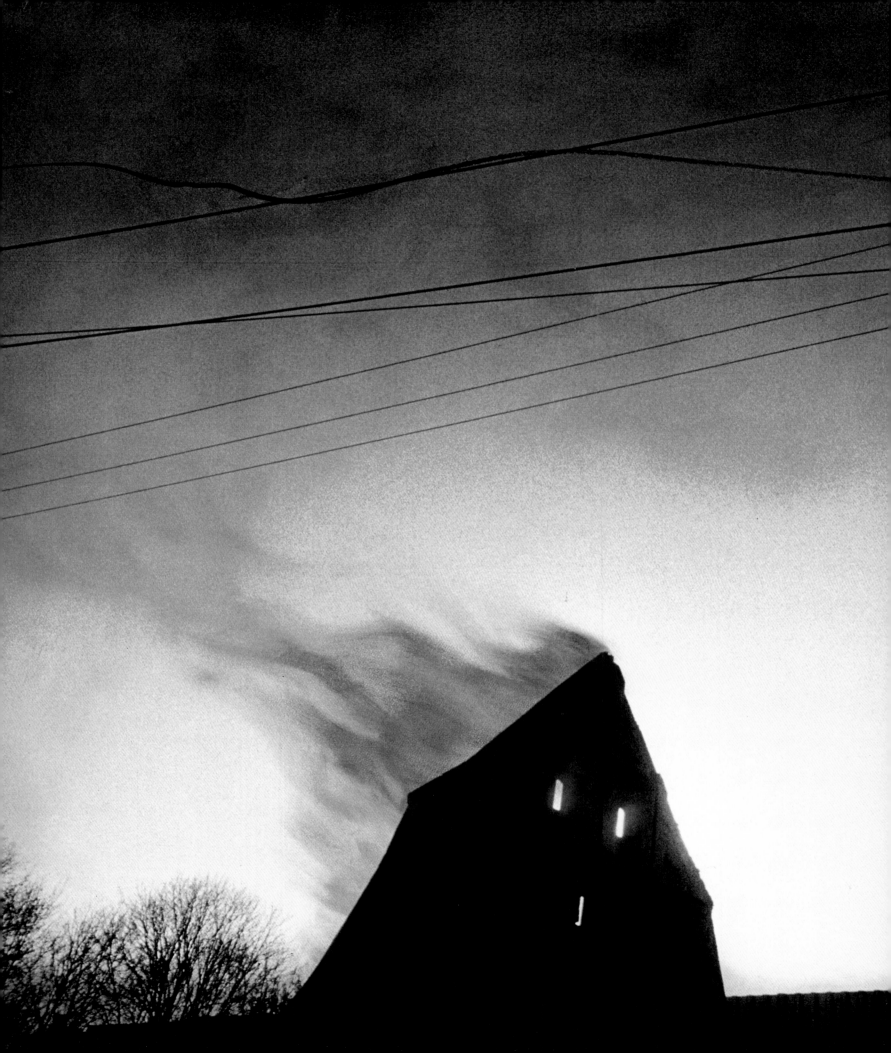

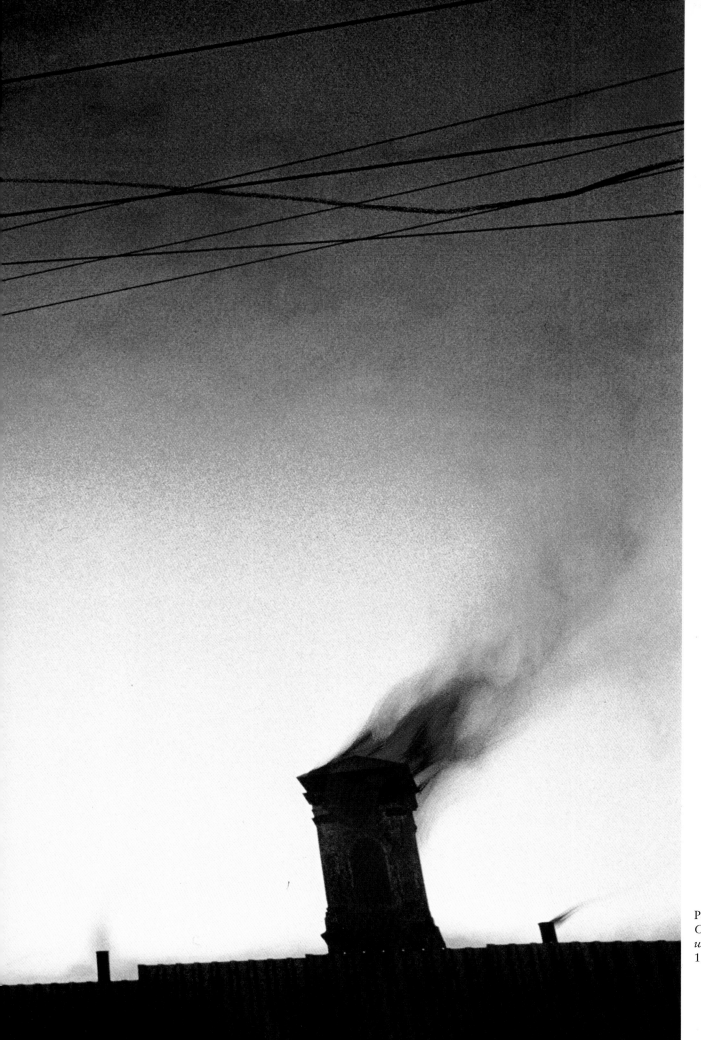

Peter Župník,
*Conversing
with the Wind*,
1987–89

CROSSING BORDERS

*I*n 1976, I ventured back into a world I had left behind a decade earlier and quickly realized that I had become a foreigner in my own country. (Even the Czech language I speak is different than what is spoken there today.) So the main point of reference I had was my pictures. When I began photographing in Eastern Europe—in Czechoslovakia, Poland, and Romania—I was a bit nostalgic; I was looking for things I remembered from my youth. But with time I became deeply involved in the life of Eastern Europe and with the other regions, which I had never known because in the '60s I could not get permission to travel there.

I was drawn to the religious rites and rituals that took place in the countryside, especially in Poland and Romania. In Czechoslovakia, which include some of the most industrialized areas in Europe, the peasant way of life was gone long ago. And with communism in place, religious practices were suppressed; many things that we take for granted in America, including funerals, had been robbed of their dignity. Even the new cemetery built next to a huge apartment block outside of Prague had a coldness, an almost sanitized feel about it.

In those little towns on the border of Poland and the Soviet Union, I saw that rituals are still a big part of ordinary life. In Romanian villages, funerals are a great occasion; everybody comes together to celebrate. Even if they do not

Antonín Kratochvil,
Palm Sunday, Poland, 1978

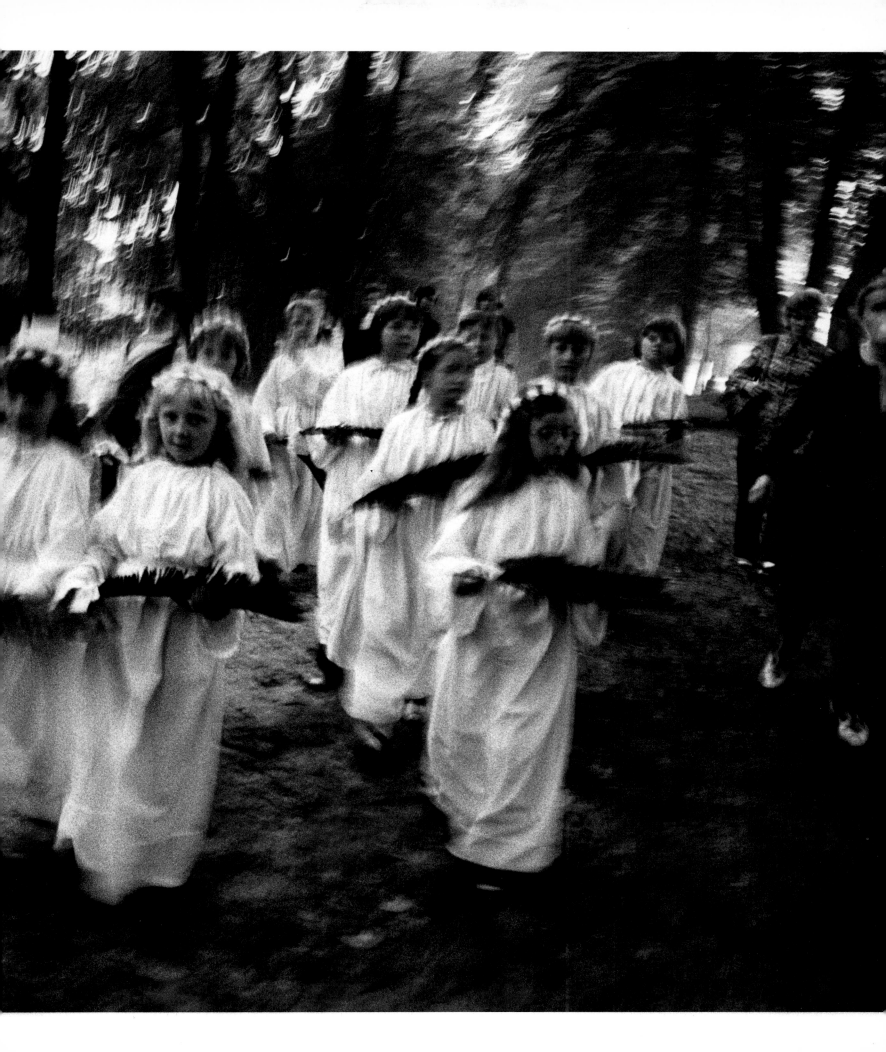

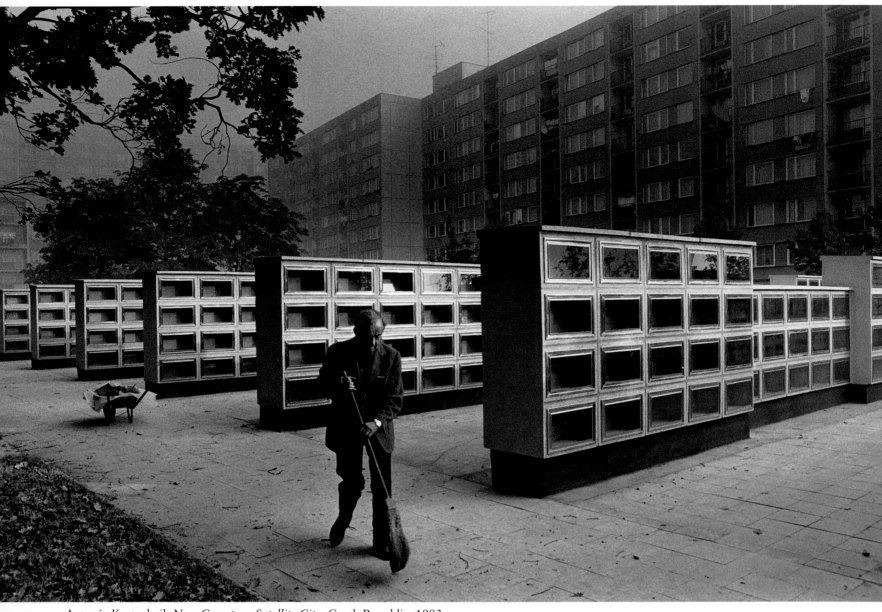

Antonín Kratochvil, *New Cemetery, Satellite City*, Czech Republic, 1993

have much, there is always a feast, and they are so generous, so proud of it. In a small town in Poland, near where I photographed the Palm Sunday procession, there is a pilgrimage every year. It's difficult to gain access because the ritual is very important to these people; they protect it from outsiders. When I went there in the '70s,

as a foreigner with a camera, I hooked up with some Polish photographers, which made it a little easier to blend in.

It was very interesting for me when I showed these photographs at Prague Castle in 1997. Although most of the people at the exhibit had not been to the places shown in my pictures, there seemed to

be a shared sense of recognition. Even with the current trend toward nationalism, I felt that the people there recognized something about the way things look and feel throughout Eastern Europe. Perhaps in some way they realized that their destinies are more alike than different.

—ANTONÍN KRATOCHVIL

Opposite: Antonín Kratochvil, In the Field of the New Gods, Romania, 1995

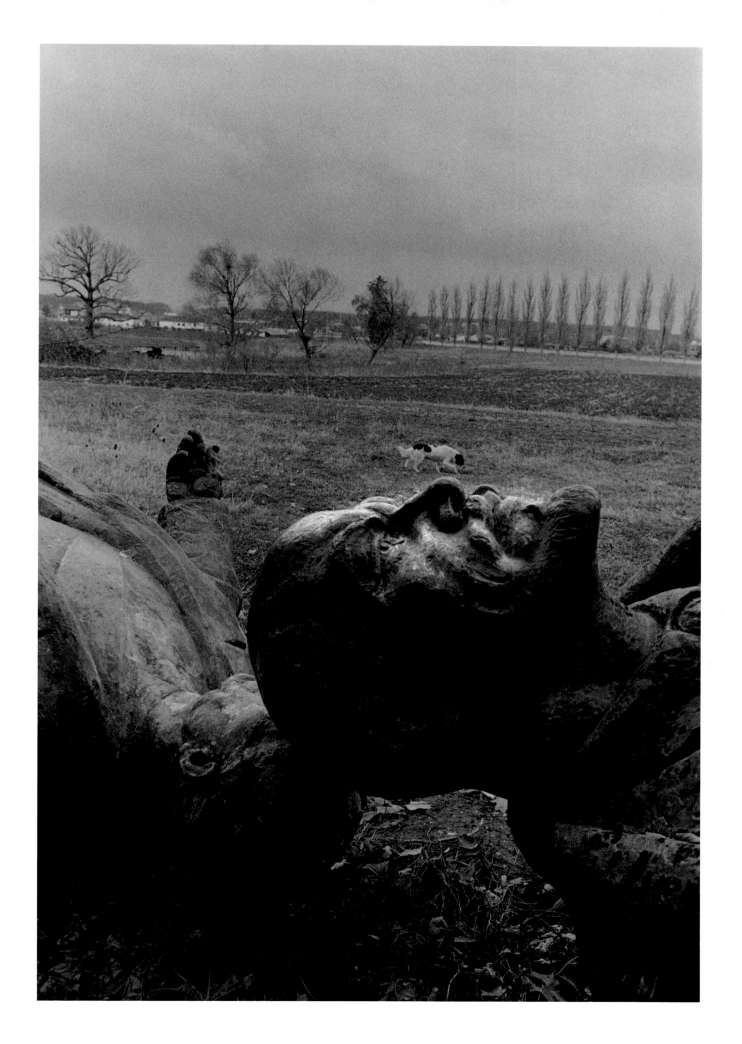

Antonín
Kratochvil,
*Chapel of
the Skulls*,
Poland, 1978

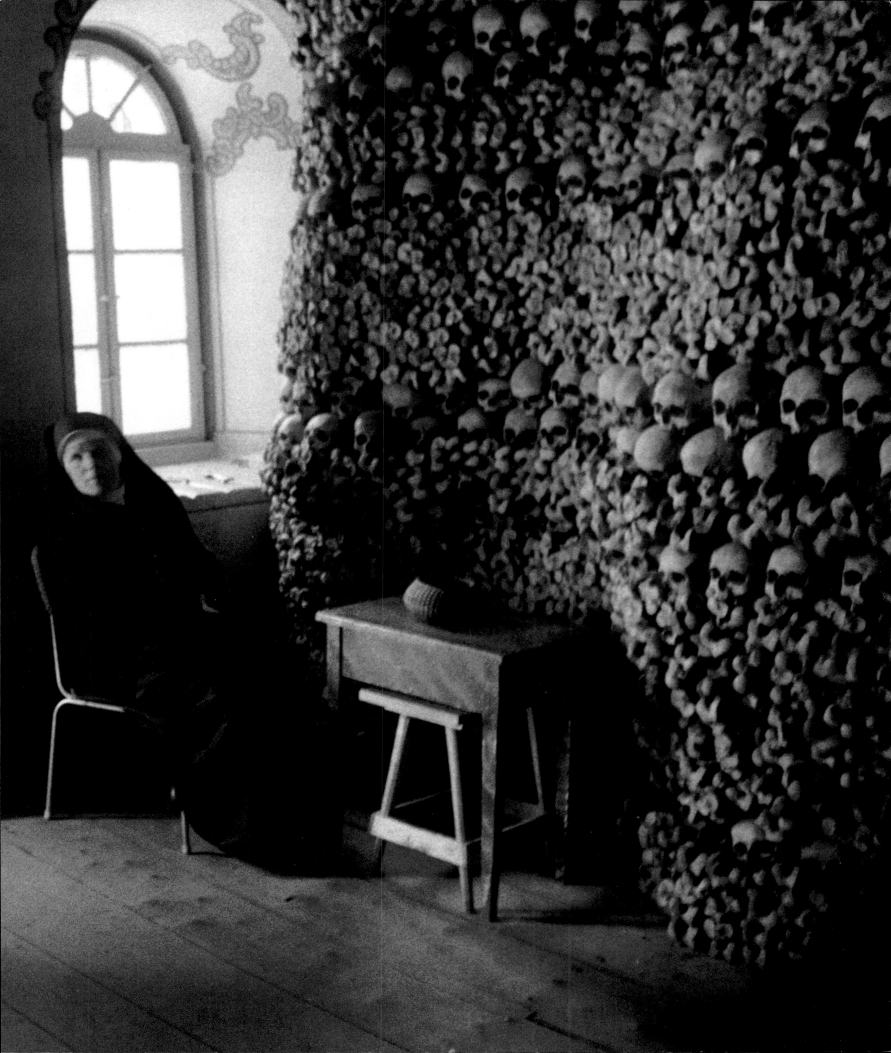

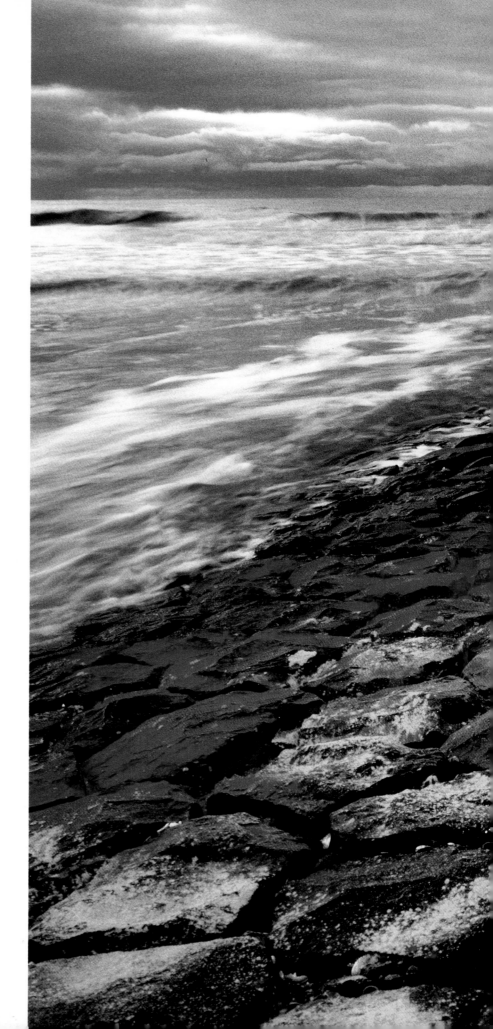

NEW STONE AGE

I complete space as space completes me.
I fly so I might perceive falling.
I mark ways and landing sites
so I might return.
I am a particle of movement,
a particle of this changing world.

"*S*tones of Magic," a series underway since
1988, reflects the relationship of man and
nature in the context of prehistory, when this
relationship was, perhaps, more natural and
encompassing. My installations—ancient stone
objects and, finally, color photographs—are
inspired by the Stone Age culture which was
mainly settled in Europe, but traces of which
are found all over the world. Signs, symbols,
magic rituals emanate from the megaliths
themselves. A belief in the power and energy
residing in these ancient relics and a deep
appreciation of the natural order might offer
relief from the chaotic world we inhabit today.
 —JAN POHRIBNÝ

Jan Pohribný, *The Original Road to America*, Schreveningen,
The Netherlands, 1990, from the series "New Stone Age"

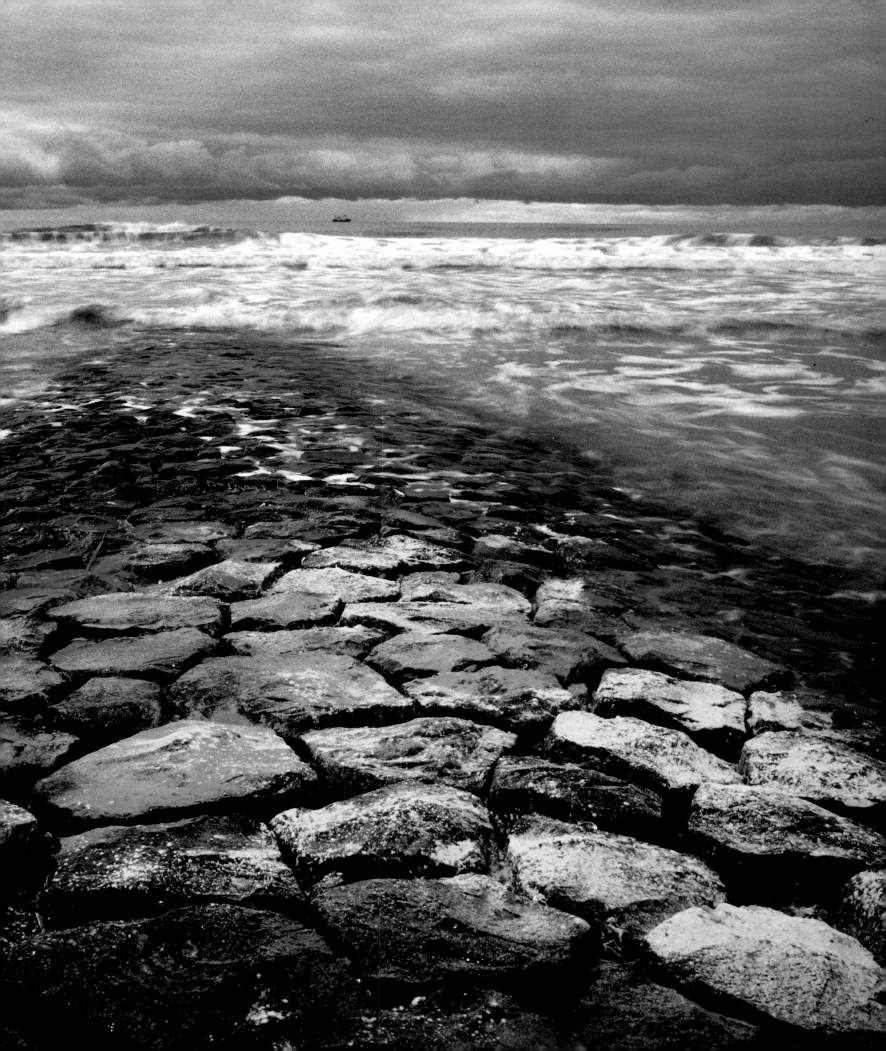

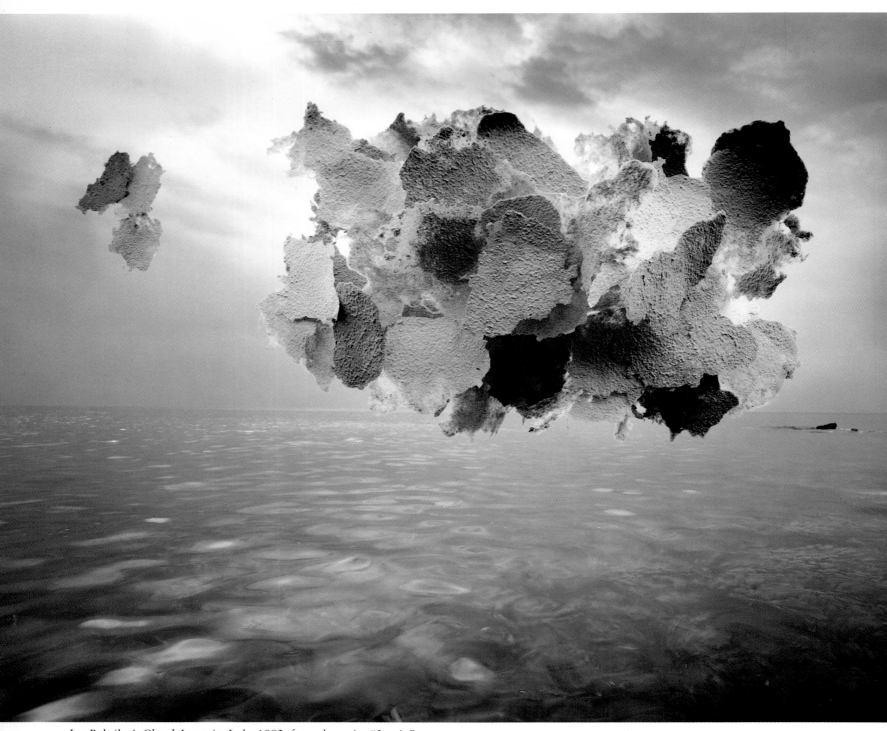

Jan Pohribný, *Cloud*, Impevia, Italy, 1992, from the series "Jancin"

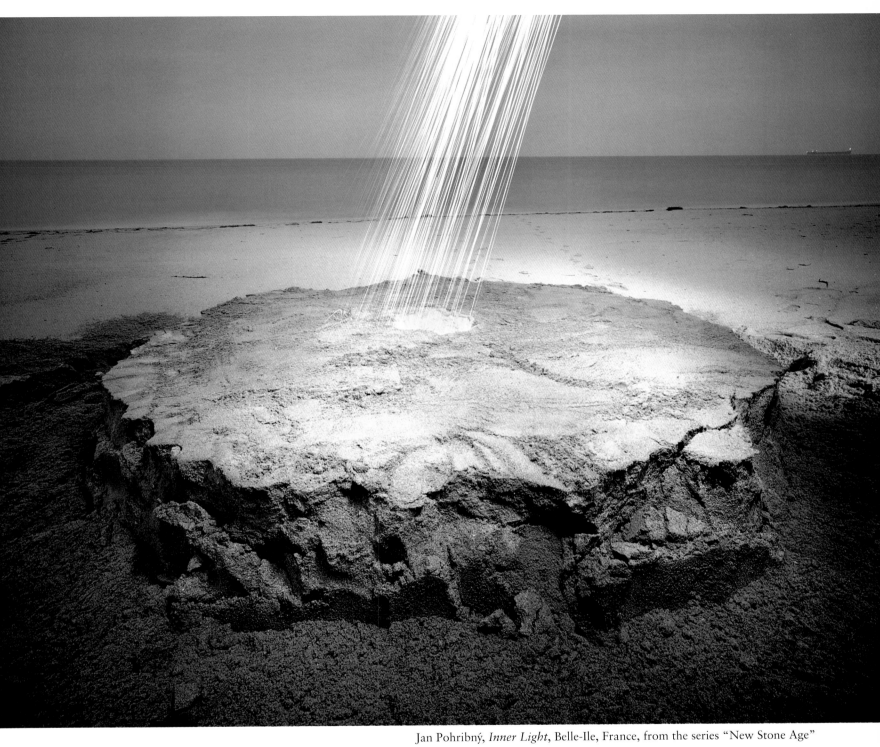

Jan Pohribný, *Inner Light*, Belle-Ile, France, from the series "New Stone Age"

Jan Pohribný,
Positive Energies Emitter,
Klobouky, Czech Republic, 1996,
from the series "New Stone Age"

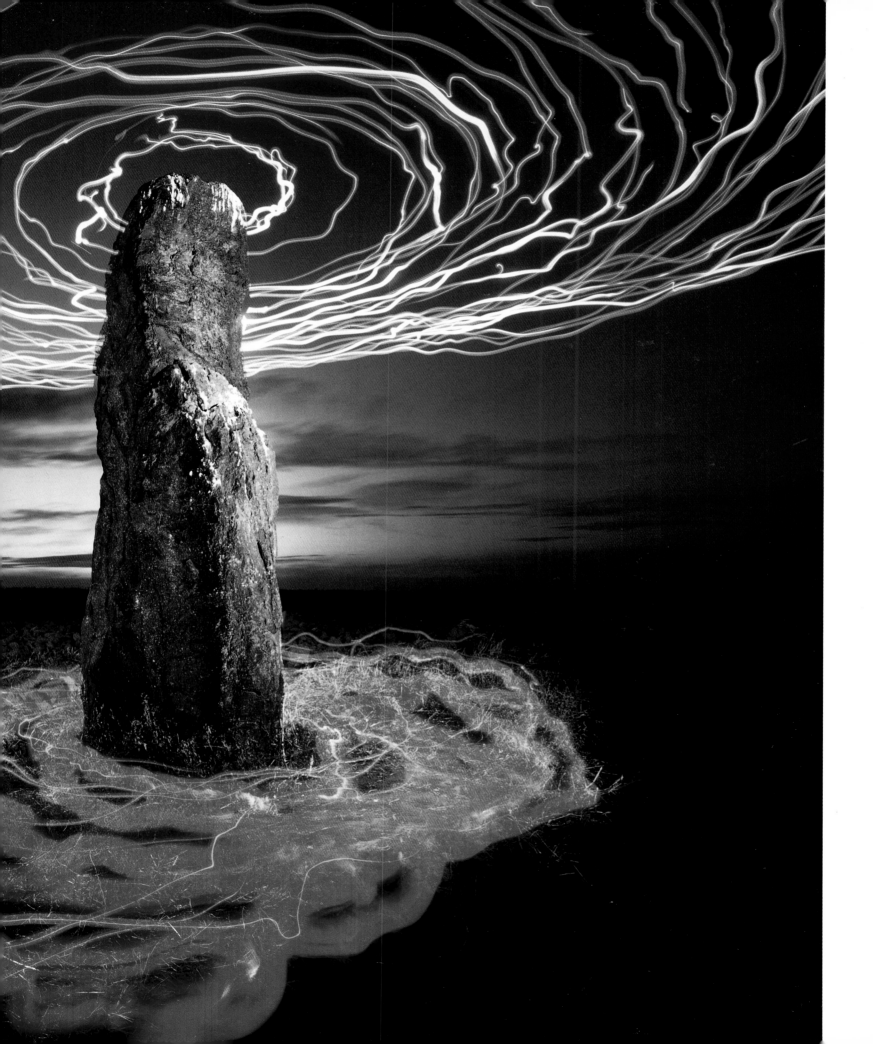

PEOPLE & IDEAS

THANKS FOR EXPLAINING ME: JACK SMITH AT P.S. 1

By Ken Jacobs

The Jack Smith retrospective, curated by Edward Leffingwell, opened at P.S. 1, Long Island City, on October 29, 1997, then traveled to the Andy Warhol Museum, Pittsburgh, in March 1998.

EDITOR'S NOTE: Film artist Ken Jacobs was an early collaborator with the legendary filmmaker, photographer, and performer Jack Smith (1932–89).

Ah, Jack, Jack. It's fallen to me to review you and I now must face doing so. This big P.S. 1 spread of your works and days doesn't stop with your things, but aims (correctly) to present you as your ultimate creation, and, like everyone you attached yourself to, I still have problems with you. For starters, with your only sometimes joking Montez Mariolatry. Co-starring Jon Hall, toothy smile winding around his head. The pits. I figure you were—as you advised—glamorizing your messes, sending up not so much these feeble luminaries as the general human capacity for foolish devotion, the longing for the unattainable—Tootsie Roll. Whatever. You fell hard for 1940s Saturday matinee junk. Orientalism for the masses; the hot parts of the Old Testament: *heady fare for a Midwest pubescent! Infuriating, wasn't it? to discover that you, too, had been "betrayed by Rita Hayworth."[1] So how is it, seeing for yourself that Maria Montez was a real nothing, you then devote a lifetime to arranging her seven veils?*

In the late '50s, Jack Smith came into his own as a photographer as well as screen performer in my and Bob Fleischner's 16mm film work. But it was his own raunchy short feature, *Flaming Creatures*, 1962, that rocketed him to both tabloid and world-class intellectualized scandal and played a significant part in kicking off the '60s.

Flaming Creatures mocks the devotees of glamour as it proclaims the faith. Faith flashes its neon promise as the flesh fails. Screeching queens circle a bobbling breast. God punishes the errant appetites: the roof caves in and the creatures are covered in plaster rubble. But Desire rises again, like Christ and Dracula, to sublimate into Eternal Moviedom.

His cinematography is of a piece with his still work of the period, stills which seem plucked from phantom, suggested, lost, achingly absent movies. Conversely, a peak extended moment of the film is when the camera *holds* on an arabesque of bodies and *keeps holding*. An imbedded "still" that encapsulates as it crowns the movie. And which happens to document exactly the conditions of much of his still photography. He sought faces that fronted busy minds. He needed to expose lives, the more broken and mended the better.

The creatures are cavorting in a skeleton dance of desire; sneering, sudden clutches. The set is often gauze-cordoned-off in tense intervals of depth. Each image jells, holding to the four sides of the screen in a miracle of surface tension. Jack's slightly atremble hand-held camera lets us in on the secret drama within the apparent commotion, as we feel along with him ever so sensitively for optimum framing positions. The camera and the scene are making love.

Yet within the scene, yucky losers—excepting Jack's voluptuous actual-female object of desire—with delusions of stardom, womanliness, beauty. It's so cheap, so down. For some passages, outdated black-and-white film-stock invites abstraction as tonal areas separate from objects and merge into larger patterns. Overexposure stresses the gossamer nature of *film*, and often the emulsion is so thin the projector light barrels right on through the scene, roaring like God's wrath.

A tantalizing now-you-see-it-now-you-imagine-it is introduced that will be missed in his later properly exposed film work (where the blast of light is sheathed and the flaming creatures drop to Earth with a dull fizz). Of course it was the overexposure of the players that attracted the law and Susan Sontag,[2] made "limp dicks" a household word, and the world safe for Warhol and for Mafia manufacture of real pornography.

Wasn't it a time! It didn't hurt Jack to ride along on the window-decorator invasion of high art. Jack's movie takeoffs were to then-avant-garde cinema what Pop was to more radical abstraction. Undemandingly outrageous, amusingly edgy, comfortably kuh-razy, the way the new Vietnam-War-profiteering art market liked. The avant-garde cinema audience was, by its liberal nature, open to Jack, to anything smacking of verve and intelligence, and did not stress the distinction between movie send-ups and more modernist developments, e.g., Tony Conrad's *The Flicker*, which is just that, rhythmic alternations of opaque black and entirely transparent film frames. And to the prurient public all film art became known as Underground Film. For a moment we were hot, and Jack hottest of all, until subsumed and eclipsed from public attention by the blithely offhand tumble of films from Andy Warhol's Factory.

Due in part to non-commercial film art's implicit demand that First Amendment rights be extended to cinema, the legalization of porn—and the passing of the hunger for Expanded Consciousness—would spell the end of any wide public interest in or even curiosity about such film. Today, truly new films—democratic rather than demagogic utterances—are brushed aside as no more than late arrivals of the '60s. No one had invited the police to the screening of *Flaming Creatures*, but Jack would blame Jonas Mekas for using his film to topple the law. Certainly a freakish result is that while it seems now that most anything can be shown in New York, *Flaming Creatures* itself is still technically verboten. (And now Queer Politics would just as well forget it. Big walkout when the film was screened 1991 at The New York Film Festival, after much applause for a Canadian agitprop that began with

the shout, "I hate Straights!" Flaccid queens out, hardbodies in. Art, shmart.)

His naive pre- and then confused post-*Flaming Creatures* film efforts are a sorry mess, with only here and there (*Putting Litter In Pool*) a good laugh, despite filmmaker Jerry Tartaglia's best efforts to rescue the films from Jack's terminal dissarray. Why sorry? Drugs, notoriety, Warhol's buyout of his minimum-wage Superstars (Jack invented the word); who knows? His next feature, *Normal Love*, went nowhere, however promising seemed some of the unedited film rolls. John Zorn thinks maybe Jack lost interest in composing films, lost interest even in making good shots, but retained his love for dressing up his performers for the shots—photographs as well as movies—and indeed some wonderful stray creature-apparitions are to be seen, all dressed up with no place to go.

Far out! Wild doings. Off-color, off-Hollywood movies. Off-Hollywood being as far out, cinematically, as Jack ever wished to get. He wanted to be understood, wanted to frame his extraordinary vision in the common language of photoplay, to figure into the great 35mm populist discourse of The Movies. The Movies are real! People live to go to The Movies! What could be the point of *a play of light* that did not serve to make a screen darling dazzle? The gods, such as they are, even as travesties of themselves, must be served. The movie audience must be served, which is to say: conventionally. And it could be that because Jack wasn't either technically or by disposition up to that task, which might have required the resources of a big-time studio (a studio that would've judged him as impossible to work with as Erich von Stroheim), he floundered. Happily, what followed the grim scuttling of *Normal Love* is that Jack's formal capacities turned to enliven/engender a territory of experimental theater (Charles Ludlum and Everett Quinton's Theater of the Ridiculous, Richard Foreman, Robert Wilson), a world-of-his-own requiring extreme audience accommodation, while he increasingly distanced himself from and became actively hostile to avant-garde cinema.

Moving through the thick of Jack's invention that fills the walls and vitrines and floor spaces of the generous P.S. 1

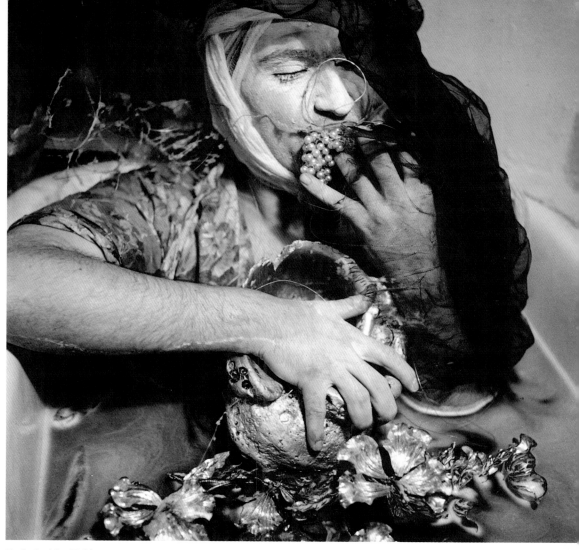

Jack Smith, *Tableaux vivant*, ca. 1957, with the author as subject

exhibition, one sees—in the photographs, writings, assemblages, collages, drawings, stage sets, fashion designs, mannequins, videos, and audio tapes—how relentlessly full-time an artist Jack was. Scurrilous, witty, transgressive, a font of today's fashionable transgressiveness in the arts. Time will tell if his transgressive energies can surmount acceptance, and what—as *works*, beyond impact as gestures within a particular social time and place—will remain.

Certainly his first decade of still photography.

Hundreds of photographs are chronologically arranged from room to room, from the late '50s—when Jack and I hung around, and so he appears in my early film work and I appear in his photographs—on into the late '80s when Jack died, age fifty-seven, of AIDS. (He told friends that he *should* get AIDS and sought it out in the public parks. Jack, ever accusing others of betrayal, was *into* betrayal, and here he betrayed himself. Jack, that was

terrible, you murdered yourself. One more unforgivable hurt.) There's a head shot of a cheerily soused old woman in a cafeteria, one of his first pictures after saving for and acquiring his Rollei (shrewdly he'd gotten office work in a photo supply wholesaler's), one of those peeks into picturesque poverty that Jack himself usually detested. (I recall his turning in contempt from a photo by Weegee, who had popped a flashbulb in the face of a Puerto Rican mother whose children were trapped in a burning building. The photo hadn't repelled him; death . . . well, that's life, we can live with death; bullshit was intolerable. The self-serving caption read, "I cried when I took this picture.") Then, suddenly, 1958 or early 1959, he springs from recording to *creating*, veering from what he probably initially construed as fashion shoots to unmarketable fantasy splendors. (Jack had fashion photographer ambitions. "Where else," he'd ask, "is there acceptance of stark pictorial design? People see it, you get paid for it." "Con-

Jack Smith, Photo collage including self-portrait, date unknown

One might say that he turns to another kind of nakedness, that of a person abandoned, with delusions exposed, like Maria Montez on a cheesy set. Gone is the integration of person and picture. It's aging Jack pinned against "exotic backgrounds," a remnant of his smarts taking the form of the self-mocking penguin doll he drags everywhere. Okay, so what's so bad? He saw the world and the world saw him. Let's not fetishize art—including photography—any more than it has been. What's important is a life, and in our absurd general predicament Jack chose to localize absurdity within the more manageable strain of glamour worship. He picked up on Maria's similar narcissism; why wouldn't he also want to investigate the reaches of her gullibility?

Jerry Tartaglia concluded a thoughtful talk at the American Museum of the Moving Image[3] with the statement, "Jack was a great gay artist." Well, I never entirely bought Jack's homosexuality. It is his abused friends, both men and women—but never acknowledged lovers—valuing the better times and the liveliness of his company, who step forth to speak of him. (Referring to sex: "I'm strapped," Jack told me early on.) Homosexuality, I suspected, was a swaggering bluff that he'd achieved sexual identity, had graduated from infantile narcissism. (So much of his appeal was his sudden dependence on you, dropping himself in a basket on your doorstep so that you might pick him up and care for him and allow him to release his hatred for his mother at you.) His art, bitterly featuring the breast, is imbued with the polymorphous perverse. Might it be that, in considering the work, one is participating in his more genuine sex life? He was a desperately inventive social isolate—a sudden stillness follows the conclusion of his pinball career—and he was a great artist.

tent counts," I countered.) Unmarketable as soon as the burlesque cross-dressing enters the shots to stay, and Jerry Sims (we see him in my film *Star Spangled To Death*, fittingly, as a prisoner of Camp Concentration) comes to dominate the images, not to mention Jack's adoption of Jerry's cacophonous madness as his own personal style. Jerry with parasol and death mask among the New Jersey sunflowers! Jack had found—Jack. And he's unerring. He shoots and develops roll after color roll, when art photography was almost entirely black-and-white, and they come up golden. Often every frame on a roll is a dreamily hilarious take. Not mere snaps of odd behavior; compositions, every edge considered.

Inexplicably, much of the early photographic work in the P.S. 1 retrospective is shown in the form of enlarged laser-copy proof sheets hanging loosely on the walls! Interesting in that it shows the camera sequence of exposures, and perhaps for some viewers the neighboring pictures set up relational resonances. But the curl of the thin shiny paper and crowded proximity of images trivializes a magnificence that demands to be accorded its proper—yes, traditional—gallery spread, as enlarged color photographs, firmly mounted and spread out for individual perusal. Let the pictures call to each other across a bit of space. They evoke movies, but shouldn't be glommed together into another unintended movielike thing. And of course proper presentation would've

filled the seven or so rooms and been a different show altogether, and I'm an ingrate for bringing this up. So let's have another show soon that does right by these whimsical wonders, now thirty to forty-plus years old, now that they're free of their moodily distrustful creator.

After the color work, made affordable by another well-chosen place of employment (an indulgent photo lab), and after we split as friends and working partners—with the exception of my taping his voice for *Blonde Cobra*—he turns to black-and-white and to ever more decorative decadent eroticism. Max Beckmann, as much as Josef von Sternberg, helps arrange the sets; Aubrey Beardsley serves tea. (These interior groupings lead directly to the filming of *Flaming Creatures*, a kind of multi-session photo shoot on one set, and, as with many of the stills, with a harem *houri* centering the compositions.) Ending the '60s, there's another stab at fashion, interesting when he draws and paints over and distortingly collages the figures. But then the photographer wants to be photographed and we see Jack, and it's Jack and more Jack. Some telling candids of his sober working self amongst his often witty and expressive posturings, before he finally succumbs to his faith and decides to *look* famous and we get direct attempts at Hollywood glamour without the saving complications of irony. It's at this point that his embroilment with photography as a crucible of personal conflict is over. Great while it lasted.

1. Puig, Manuel. *Betrayed By Rita Hayworth*, New York, Dutton, 1971. Translated by Suzanne Jill Levine.
2. Sontag, Susan. "Notes on Camp," from *Against Interpretation and Other Essays*. New York, Farrar, Straus & Giroux, 1966.
3. The American Museum of the Moving Image, Long Island City, presented the first complete retrospective of Smith's restored films, curated by J. Hoberman, which ran from November 29 to December 14, 1997.

MEANS TO AN END: PETER GALASSI
ON THE PHOTOGRAPHIC WORK OF ALEKSANDR RODCHENKO

By Maureen Clarke

On the occasion of Aleksandr Rodchenko, *the exhibition at the Museum of Modern Art in New York,* Aperture *spoke with Peter Galassi, Chief Curator, Department of Photography at MoMA, who co-curated the show with Magdalena Dabrowski, Senior Curator, Department of Drawings, and Leah Dickerman, Assistant Professor of Art History, Stanford University. The exhibition, which opened in June 1998, shows Rodchenko's diverse career as a coherent whole for the first time in the U.S., and includes the constructivist artist's work in painting, sculpture, drawing, collage, and design, as well as photography.*

MAUREEN CLARKE: What prompted Rodchenko, the painter and sculptor, to become interested in photographic collage and photography?
PETER GALASSI: To advanced artists in the '20s in Europe, photography was appealing because it was up-to-date, it was mechanical and therefore perceived as impersonal and objective, it was engaged with the world outside the artist's studio, it was able to reach a wide audience, and it was free of the aesthetic pieties of the past in the wake of World War I, which inspired such a break. In Russia at this time, just after the Bolshevik Revolution,

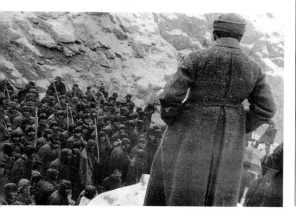

Aleksandr Rodchenko, Guard and prisoners. From a series on the construction of a canal between the White Sea and the Baltic Sea for the magazine *SSSR na stroike (USSR in Construction no. 12),* 1933.

the avant-garde especially valued photography because they felt that the scientific objectivity of its mechanical processes made it a more socially universal medium than painting or sculpture.

By the early '20s, photography had been revolutionized as well. With the advent of the dry plate in the 1880s, photography had become truly democratic. The previously slow and messy development process and the need for a tripod were eliminated, which ushered in versatile hand-held cameras such as the Leica. The same time period saw the development of photomechanical technology which allowed for photographs to be translated into ink on paper. Finally, advances in printing technology enabled the press run of, say, a daily newspaper to reach into the millions.

By 1921, Rodchenko had altogether renounced painting and sculpture as outmoded, bourgeois arts, and eventually turned instead to photographic collage, photography, and design—of everything from clothing to candy wrappers. In theory, he and the other constructivists were rejecting the self-sufficient, self-contained aesthetic object and devoting themselves to industry. In the belief that the whole world was going to change in light of the revolution, they thought they could hasten this new society into being by making new things for a new man. Photography was one of the available tools for realizing this new society.

MC: How did Rodchenko's work as a collagist influence his photography?
PG: The technique of collage was part of the cubist vocabulary, which Rodchenko had received from Kasimir Malevich and Vladimir Tatlin, and as he turned away from painting his collages began to incorporate a wide variety of vernacular graphic material, including photographic imagery from magazines and newspapers. His collage work accustomed him to this view of the photograph as raw material—to be cut up or blown up as an art director would do when fitting the image into a larger design. He began making

photographs to use in his own collages, and so from the first he regarded the photographic image as highly malleable, not something pure and inviolable. This experimental attitude continued to prevail when he began to make photographs independently of his collage work.

Until 1923, Rodchenko had worked with two large, tripod-bound cameras. In 1923 or '24, though, he acquired a Kodak Vest Pocket, and on a trip to Paris in 1925, he brought back a 4x6.5 cm Ica and a 35 mm Sept, a hand-held movie camera that could also take still frames. These small cameras allowed him to move more freely. In 1928 he acquired a Leica, which was smaller and easier to handle than the Ica and the Kodak and boasted thirty-six pictures to a roll. He could make several frames in succession without deciding in advance whether he would eventually choose one and discard the rest or would incorporate two or more frames into the finished work.

MC: You've said that the oblique perspective favored by Rodchenko simplified one of photography's most demanding challenges: to translate three dimensions coherently into two. What do you mean?
PG: A photograph renders three dimensional space in two dimensions. The more complicated the scene (in spatial terms), the more difficult it is to control this transformation formally—to make the image coherent. When you are looking straight up (as Rodchenko was when he made his pictures of pine trees at Pushkino in 1927) or straight down (as in Rodchenko's picture called *At the Telephone*), the pictorial space tends to collapse. As a result, the image is much easier to control. It is a matter of arranging the elements against the two-dimensional field.

MC: Would you talk about Rodchenko's photographic prints?
PG: Rodchenko was engaged in an irreverent experiment. As I've said, he was anything but a purist with regard to photography, and the character of his prints—the kind of paper he used, its color and surface texture, the printing style—is as diverse as I've seen in any body of photography. To some degree, this variety is explained by the variety of functions his pictures served. For example, a print intended for reproduction in a magazine or newspaper might be an

Aleksandr Rodchenko, *At the Telephone*, 1928.

8x10-inch glossy, whereas a print from the same negative intended for exhibition might be larger, with a matte surface.

As a result of this diversity, the connoisseurship of Rodchenko's photographs is still somewhat primitive, and one of the goals of the exhibition is to help clarify it. In selecting the exhibition, my colleagues and I worked from two directions: first, from the body of imagery known through reproduction; second, by viewing actual prints in a large number of collections from Moscow to the West Coast of the United States. You look at one group of photographs, including types of prints that you've never seen before, and you formulate a hypothesis about why each

prints looks a particular way. Later you see another batch and realize that the hypothesis was wrong. There is a great deal more work to be done, but we believe it will be a revelation—for ourselves as well as for others—to see excellent examples of many of the best pictures together in one place for the first time.

In the exhibition, we decided to limit our exploration of variant prints to a single, very interesting case. Rodchenko's first lasting achievement as a photographer was a series of six portraits of his friend, the poet Mayakovsky, which he made in the spring of 1924 in anticipation of further photo collage projects with the poet. The negatives are 9x12 cm, or about

4x5 inches, and the early prints are either contacts or modestly scaled, straightforward prints. After Mayakovsky's death in 1930, his life became the subject of a myth of revolutionary heroism, fostered by Stalin. In the service of this myth, Rodchenko began to print his portraits in warm, romantic tones, and often in size reaching two feet or more high. The exhibition will include two prints each of four of the portraits—one representing the way Rodchenko treated the picture before 1930, the other, the way he treated it in the '30s—or so we believe.

MC: Where did Rodchenko publish and exhibit his photographs?

PG: At first he published in avant-garde art periodicals such as *Sovetskoe Foto* and *Novyi Lef*. Toward the late '20s, he turned more and more to propaganda photojournalism. In 1929, for example, he did a photo reportage on the first Soviet auto factory, called AMO, for a magazine called *Daesh'*, which roughly translated means "Give Your All."

Rodchenko also exhibited his photography regularly in Moscow, especially during the '30s, when photographic exhibitions played a significant role in Soviet culture. In addition, through VOKS, the agency charged with promoting Soviet art abroad, which established a photographic division in 1927, he sent photographs to a wide range of exhibitions—everywhere from Belgium to the United States to Japan. This continued until WWII.

MC: How did the rise of Stalin affect Rodchenko?

PG: Rodchenko's work first came under attack by the Communist regime—as Western bourgeois formalism—in 1928, and he continued to be attacked through the early '30s. This was part of a broad phenomenon of these years, which has come to be called the cultural revolution. In effect, once Stalin achieved power, he fomented a climate of class antagonism, which successfully discredited so-called "bourgeois experts" in all fields of the society. The new bureaucrats who took their places entirely owed their prominence to the Communist Party and so were far more loyal to Stalin. The marginalization of the avant-garde in the arts was part of this process.

From 1920 to 1930 Rodchenko earned his living as a teacher at VkhuTeMas (an

acronym for the state art school) in Moscow. In 1930, Stalin closed the school, so that Rodchenko was obliged to look for other means of support. In 1932—the year that all independent artistic organizations were outlawed—he signed a contract to supply photographs to the state art publishing house, IZOGIZ.

Already in the late '20s Rodchenko had responded to the attacks upon his work by devoting more and more of his energy to propaganda photojournalism. In 1933 he accepted a commission from *SSSR na Stroike* (*USSR in Construction*) to photograph the building of a canal from the White Sea to the Baltic Sea. The pictures appeared in the December 1933 issue, which Rodchenko also designed. The project was the first of Stalin's major gulags, in which some two hundred thousand people died in the course of a year or so. The propaganda associated with the canal project was that it was an opportunity for the people who worked on it, and who earlier had strayed from the true path of communism, to redeem themselves through hard work. It seems that Rodchenko believed, or convinced himself, to believe this—and indeed to believe that he himself needed to be reformed.

In fact, Rodchenko was briefly rehabilitated in 1935, in association with a major exhibition of work by the masters of Soviet art photography. He was a member of the jury for the exhibition, which prominently displayed his work. Nevertheless, he continued to slip into the margins of Soviet culture. In the mid-thirties this great innovator, who had renounced painting as an outmoded art, began to paint again—not abstract works but imaginary circus scenes. This is the surest sign that he had become alienated from the common cause that had fueled his best work. Like millions of other Russians, he suffered badly during World War II, and he never fully recovered. He died a bewildered man in 1956.

MC: How does Rodchenko's photography compare to that of Leni Riefenstahl?
PG: Rodchenko's sports and parade photographs of the '30s are very similar stylistically to Riefenstahl work on *Olympia*. The great irony is that, even as Rodchenko was being discredited as a bourgeois formalist around 1930, his modernist style was being adapted as the model of Stalinist photographic propaganda. In fact, this was a worldwide phenomenon. Rodchenko's work for Stalin's regime, Riefenstahl's work for Hitler, and Margaret Bourke-White's work for Henry Luce at *Fortune* and *Life* are all of a piece—even though each served a very different ideology.

MC: Is there anything you would like to add?
PG: For me, the greatest challenge of working on the exhibition, and also the greatest reward, was to struggle with the relationship between Rodchenko's work and the fortunes of the political ideals it was meant to serve. It is important to remember that the Bolshevik Revolution overthrew an archaic, brutal, repressive regime. In identifying his work with the ideals of the Revolution, Rodchenko embraced an illusion and soon enough suffered dearly for it, but his ideals were noble and they were accompanied by a powerful optimism that spurred his remarkable creativity. In attempting to grasp that optimism, we must also come to terms with the brutality with which it was crushed—with the great human tragedy of Stalinist Russia. Both the hope and its defeat were well beyond what most of us have experienced.

NOTES FROM PAGE 31

1. Antonín Dufek: *Jaromír Funke, Jaroslav Rössler, 27 Contemporary Czechoslovak Photographers*; catalog, The Photographers' Gallery, London, 1985. Steve Yates, *Protomodern Photography*; catalog, Museum of Fine Arts, Museum of New Mexico, Santa Fe; and International Museum of Photography at George Eastman House, Rochester, 1992. Antonín Dufek and Jaroslav Anděl, "Remaking the Photogram: The Pioneering Work of Jaroslav Rössler and Jaromír Funke," in *Czech Avant-garde Art 1918–1938*; catalog, IVAM, Valencia, 1993, pp. 144–151. Antonín Dufek, *Jaromír Funke: průkopník fotografické avantgardy / Pioneering Avant-garde Photography*; catalog, Brno, Moravská galerie, 1996.

2. Christian Peterson and Daniela Mrázková, *The Modern Pictorialism of D.J. Ruzicka / Moderní piktorialismus D.J. Růžička*; Minneapolis/Prague, 1990.

3. František Šmejkal, Rostislav Švácha, et al., *Devětsil: Czech Avant-garde of the 1920s and '30s*; catalog, Oxford, Museum of Modern Art, and London, Design Museum, 1990.

4. Antonín Dufek, "Imaginative Photography," in Jaroslav Anděl, Anne Tucker, ed., *Czech Modernism 1900–1945*; catalog, Museum of Fine Arts, Houston, 1989, pp. 122–147. Monika Faber, ed., *Das Innere der Sicht: Surrealistische Fotografie der 30er und 40er Jahre*; catalog, Museum of Modern Art, Vienna, 1989.

5. Jaroslav Anděl, "Construction et 'poétisme' dans la photographie tchèque / Construction and 'Poetism' in Czech Photography," *Photographies* no. 7, 1985, pp. 21–25, 121–124. Jaroslav Anděl, "The 1920s: The Improbable Wedding of Constructivism and Poetism," in *Czech Avant-garde Art 1918–1938*; catalog, IVAM, Valencia, 1993, pp. 21–119. Jaroslav Anděl, "The 1930s: The Strange Bedfellows, Functionalism and Surrealism," Ibid., pp. 292–390.

CONTRIBUTORS

PAVEL BAŇKA, (b.1941, Prague) was a founder of the Action Group of Free Photography (1989) and the Prague House of Photography (1991). His work is in the collections of the Art Institute of Chicago, the San Francisco Museum of Modern Art, and the Ludwig Museum, Cologne.

JUDITA CSÁDEROVÁ received a degree in photography from the Academy of Film and Performing Arts in Prague in 1974. In addition to freelance photography and teaching at the School for Applied Arts in Bratislava, Csáderová organizes photography events.

ANTONÍN DUFEK (b. 1943, Brno). Art historian and curator of photography at the Moravian Gallery since 1968, Dufek has organized nearly 100 photography exhibitions. His recent publications include: *Josef Sudek, The Quiet Life of Things: Photographs from 1940–1970*, from the Moravian Gallery, Brno (Kunstmuseum Wolfsburg/Cantz Verlag, 1998) and *Jaromír Funke—Pioneering Avant-Garde Photography* (Catalog, 1996, Moravian Gallery, Brno).

BOHDAN HOLOMÍČEK (b. 1943, Sienkiewiczowka) is a self-taught photographer who worked as an electrician and as a geographical surveyor before making photography his full-time occupation in 1994.

KEN JACOBS is a film artist whose work was the subject of a 1989 retrospective at the Museum of the Moving Image, Astoria. Professor of Cinema at Binghamton Univesity, Jacobs is a Guggenheim and National Endowment for the Arts grant recipient.

IVAN KLÍMA (b. 1931, Prague) edited the journal of the Czech Writers Union during the Prague Spring. His plays, short stories and novels were banned in Czechoslovakia until 1991. Klíma's most recent novel is *Ultimate Intimacy* (New York, Publishers Group West, 1997).

VIKTOR KOLÁŘ (b. 1941, Ostrava) lived in exile in Canada from 1968–1973, working in coal mines and as a freelance photographer. After his return to Czechoslovakia, he continued his freelance career. Kolář's work is included in the collections of the Moravian Gallery, Brno; the Ludwig Museum, Cologne; and the Victoria and Albert Museum, London.

JOSEF KOUDELKA (b. 1938, Boskovice) has lived in Paris since 1980. He is a member of Magnum Photos and has had one-man shows at the Museum of Modern Art, New York (1975) the Museum of Decorative Arts, Prague (1990), and the Museum of Modern Art in San Francisco (1991). His photography has earned the Henri Cartier-Bresson Prize (1991) and the Hasselblad Foundation Prize (1992). Aperture has published Koudelka's books *Gypsies* (1975) and *Exiles* (1997).

ANTONÍN KRATOCHVIL (b. 1947, Lovisice) recently published *Broken Dreams* (New York: Monacelli, 1997), which presents twenty years of his work documenting Eastern Europe during the Cold War. His photography in this field has earned numerous awards including the Infinity Award from the International Center of Photography (1991), the Leica Medal of Excellence (1994), and most recently, the Alfred Eisentstadt Award (1998). He is currently working on a project entitled "Misery."

J.H. KRCHOVSKÝ (b.1960, Prague) identifies himself as the poet of the Prague underground. Between 1978 and 1991 he published ten poetry collections (most in *samizdat*), from one of which the poem in this issue was selected.

ZDENĚK LHOTÁK (b. 1949, Turnov), a freelance photographer, is currently chairman of the board of directors at the Prague House of Photography, a post he has held since 1993. His works are in the collections of the Museum of Decorative Arts, Prague, the University of Texas, Austin, and the Musée de l'Elysée in Lausanne.

JAN MALÝ, JIŘÍ POLÁČEK and IVAN LUTTERER studied together at FAMU (Film Academy of Performing Arts) in Prague in the 1970s. After graduating, each artist chose separate paths in photography; but three times each year for the past sixteen years, they have set out in their mobile studio to work on the "Czech Man" project.

PAVEL MÁRA (b. 1951, Prague) studied cinema and photography from 1967–71 at FAMU, where he now teaches. His work has been the focus of numerous individual exhibitions at galleries in Prague, Regensberg, and St. Petersberg.

JAN NOVAK is a Chicago writer who is often tugged back to his Czech origins. The Czech translation of his last book, *Commies, Crooks, Gypsies, Spooks & Poets* (Steerforth Press, 1995), was published in Prague in 1997.

ANNA ONDREJKOVÁ (b. 1954) is the author of *Kým trvá pieseň* [While the Song Lasts], (1975); *Snežná nevesta* [Snow Bride], (1978); *Plánka* [Wild Child], (1984) and *Sneh alebo Smutná jobloň piná nedozretých párov* [Snow or A Sad Apple Tree Full of Unripe Peacocks], (1993).

PAVEL PECHA (b.1962, Kremnica) studied photography at the Photography Institute in Olomouc from 1984–87. During his education at FAMU in the 1990s, the content of his work evolved toward a concern for the Absurd, a theme which informs his photographs published here.

IVAN PINKAVA (b.1961, Náchod) was one of the founders of the Prague House of Photography. His images are included in the collections of the Victoria and Albert Museum, London; the Gernsheim Collection, Austin; and the Maison Européenne de la Photographie, Paris.

JAN POHRIBINÝ (b. 1961, Prague) is a member of the Prague House of Photography, where he organizes exhibitions and teaches summer workshops.

RUDO PREKOP (b. 1959, Kosice) worked on the establishment of the Andy Warhol Museum of Modern Art in Medzilaborce. In 1994, Predop's monograph was published by the Martin publishing house in Osveta.

VASIL STANKO (b. 1962, Myjava) studied photography at the Academy of Fine Arts, Prague. He has shown his work at numerous galleries in the Czech Republic and in group exhibitions at the Art Institute of Chicago; Kunst Haus, Hamburg; and Galerie Marzee, the Netherlands.

TONO STANO (b. Zlaté Moravce, 1960) studied photography at the Secondary School of Applied Arts and FAMU. In 1995, the National Museum of Technology, Prague presented Stano's work in an extensive one-man exhibition.

KAMIL VARGA (b. Štúrovo, 1962) studied photography at The School of Applied Arts (1978–1982) and FAMU (1982–1989), both in Prague. In 1997, his monograph by Václav Macek was published in Slovakia.

PETER ŽUPNÍK (b. 1961, Levoca) studied applied photography at the Secondary School of Applied Art in Kosice, Slovakia from 1976–1980 and then artistic photography from 1981–86 in Prague at FAMU. Župník currently lives and works in Paris.

ACKNOWLEDGMENTS

Aperture is deeply grateful to H. E. Alexandr Vondra, Ambassador of the Czech Republic to the United States, Washington, D.C., and Marcel Sauer, Cultural Attaché, for their support of this project. Among the many who shared their insights and expertise, we especially thank Antonín Kratochvil in New York and Prague; Jan Novak in Chicago and Prague; Antonín Dufek in Brno; and Alex Zucker, on the Internet. Thanks to Anne Arden McDonald for her invaluable assistance with Slovak photography; Vladimir Birgus for bringing so many Czech and Slovak photographers to our attention; and Dr. Anne Baruch, for her advice. We are grateful to the talented photographers whose work we were not able to include in these pages; viewing their images contributed much to our understanding of contemporary Czech and Slovak photography.